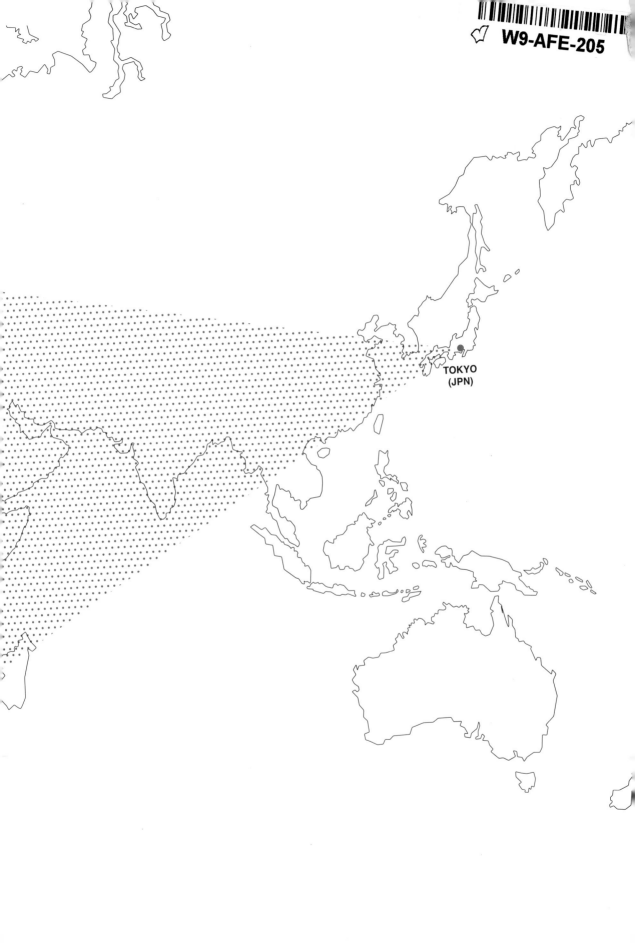

TOKYO
(JPN)

**Money and Tough Love
On Tour with the IMF**
by Liaquat Ahamed

Copyright © Liaquat Ahamed,
2014

Copyright design © Visual
Editions and magCulture

Copyright photography
© Eli Reed

Published by Visual Editions

ISBN 978-0-9565692-7-1

**Writers in Residence,
Founder**
Alain de Botton

Visual Editions, Directors
Anna Gerber & Britt Iversen

Art Direction
magCulture

Magnum Photos London
Ruth Hoffmann

Design
Jeremy Leslie

Design Assistant
Rhys Atkinson

Editorial Assistant
Leah Cross

Proofreader
Hannah Gregory

Editorial Intern
Alice Kewellhampton

Design Intern
Kathryn Evans-Prosser

Typography
Chronicle & Knockout
by Hoefler & Frere-Jones
Apercu by The Entente

Maps and graph
Nathalie Lees

Printed by
Taylor Brothers,
Bristol UK

Distributed by
Turnaround Publisher Services
Publishers Books West

VISUAL EDITIONS

MAGCULTURE

1990

- - - - US MZ • • • • • • JPN IRE

Money and Tough Love
by Liaquat Ahamed

ON TOUR
WITH
THE IMF

2010

2000

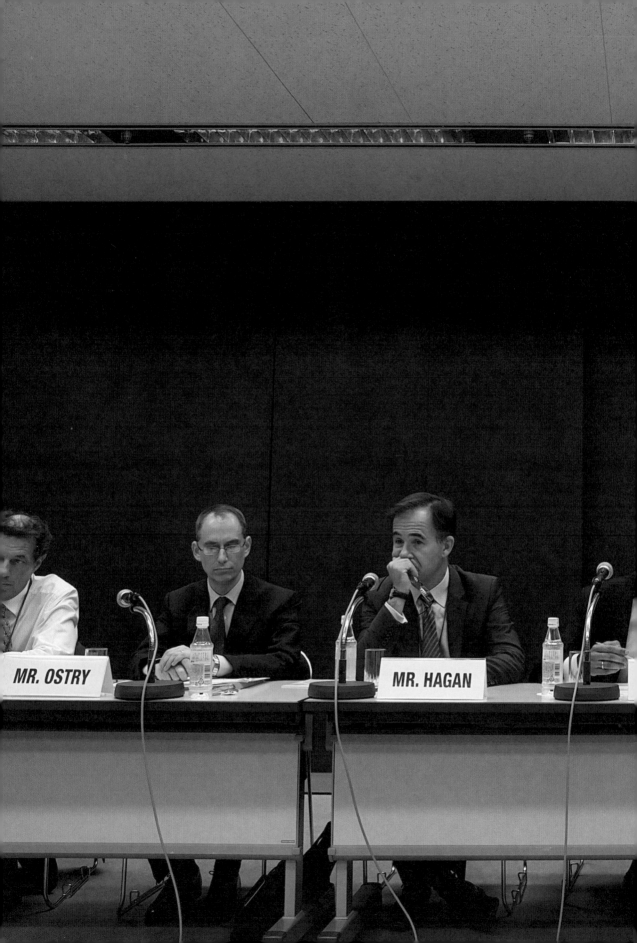

Money and Tough Love
by *Liaquat Ahamed*

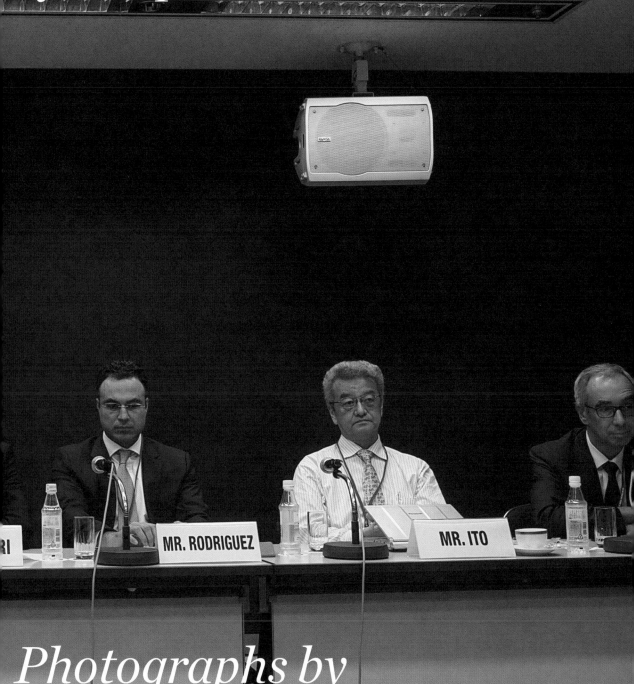

MR. RODRIGUEZ MR. ITO

Photographs by
Eli Reed

To Meena

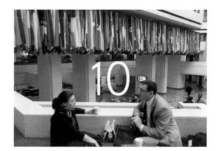

Washington,DC

Tokyo

Dublin

Maputo

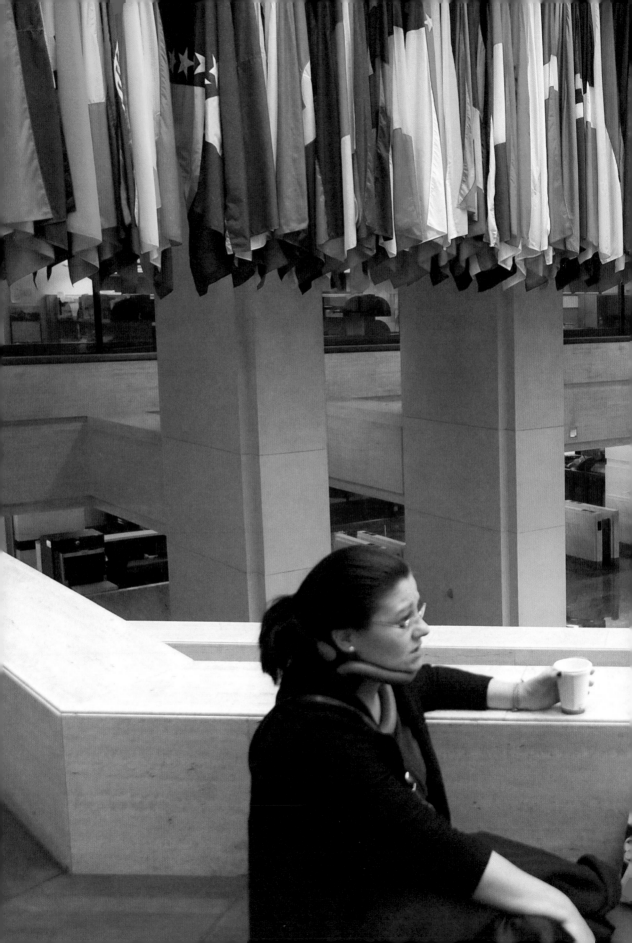

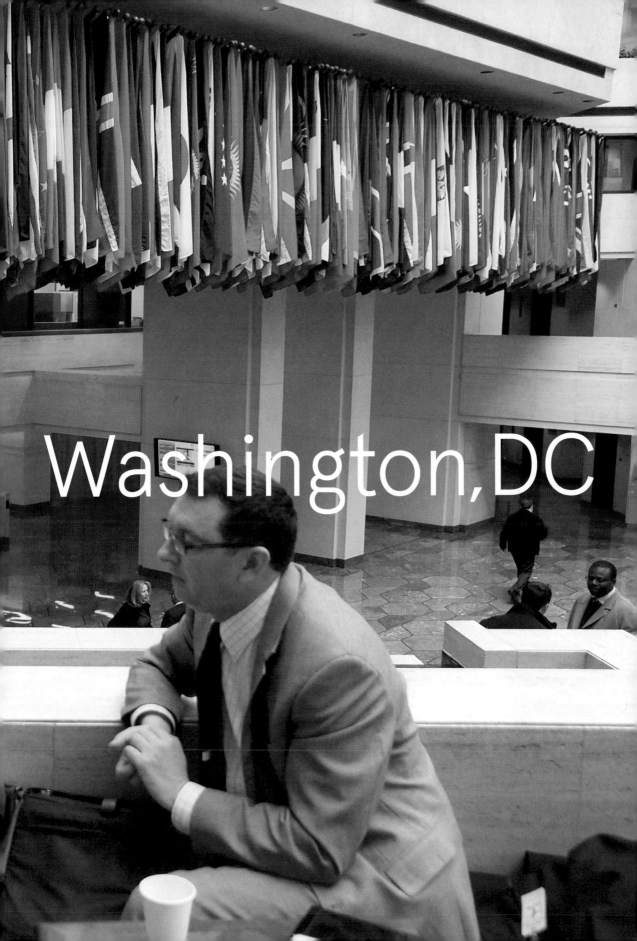

Washington, DC

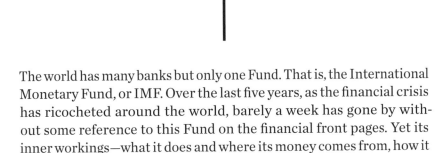

The world has many banks but only one Fund. That is, the International Monetary Fund, or IMF. Over the last five years, as the financial crisis has ricocheted around the world, barely a week has gone by without some reference to this Fund on the financial front pages. Yet its inner workings—what it does and where its money comes from, how it operates and who runs it—remain a mystery to most people.

The Fund and I go back a long way. We had our first encounter back when I was a student in graduate school, beginning a summer internship in Washington DC. A friend who worked at the Fund invited me for lunch: the IMF cafeteria supposedly had the best institutional food in DC, a reflection, it was said, of the many Europeans amongst the staff.

In the innocent days before 9/11 one could stroll into the Fund's building without showing ID. It was a gorgeous spring day, and I arrived at the IMF offices early. As I waited in the large entrance atrium, below the flags of all the member countries, I saw my friend approaching, accompanied by a young Indian woman with big beautiful eyes, and as I would discover over lunch, a vivacious personality. The woman was called Meena, and today she is my wife.

It is not surprising, then, that I hold an unusually sentimental attachment to the Fund, an institution more often associated with number crunching and debt than with true love.

As I set out to research the IMF for this book many years later, I soon discovered that gaining access to the world behind its doors would not be easy. The Fund is the repository of many secrets, which it guards ferociously. It does its work behind the scenes, out of the public eye, and has a history of being wary of the press. I wrote a letter proposing my idea. Once or twice I was invited to come in to state my case, but mostly I waited, as the proposal wended its way through the bureaucracy. An IMF insider friend warned me that there was little chance they would agree. "What's in it for them?" he asked.

Liaquat Ahamed

"There is too much downside and very little upside."

After several long months, I was invited to meet with Christine Lagarde, the charismatic French woman who had been appointed Managing Director the previous year. She received me alone, without any aides, in her spacious office on the 12th floor of the IMF headquarters. Tall and elegant, with her shock of white hair and chic clothes—Chanel is her favourite designer, according to the press—she cut a striking figure. Previously the French Minister of Finance, Lagarde is such an intriguing person to encounter in the highest reaches of global finance that I had to remind myself, as my curiosity was piqued, that I was not there to ask the questions but to be interviewed myself.

True to her reputation for no-nonsense directness, she dispensed with small talk. She had read the three-page proposal I had submitted and asked me to expand. I went through my script once again: my goal was to shine a light on the Fund, to make the place more transparent to a wider public. I was not planning a policy book that would evaluate what they did, nor did I want to write what journalists call a "tick-tock" book, a fly-on-the-wall account of who did what during the various financial crises in which the Fund was involved. Instead I wanted to capture how the place worked on a day-to-day basis. I was not aiming to profile the senior management—this was to be a piece about the troops not the generals.

Though we talked about the pros and cons of transparency—whether the Fund benefited from a certain mystique that could be lost by too much openness—it was apparent that Mme. Lagarde had not invited me to meet here to rehearse arguments which she had clearly already considered. She needed to understand a little better just what I was really up to. Almost every profile of Christine Lagarde remarks on her charm, but to be truly successfully charming one must be able to read people. I had little doubt based on her career that Mme. Lagarde was an astute judge of character. And it did not take her long to gauge that I was unlikely to be a troublemaker. I did not even have to tell her the story about meeting my wife in the IMF cafeteria.

A few days later I received word that permission had been granted.

A

As I arrived at the IMF's headquarters in Washington in the late summer of 2012, the papers reported that the IMF found itself once again

20

Money and Tough Love

in the thick of a three-cornered negotiation over what to do in Greece. Discussions between the Fund and the newly installed government in Athens over pay cuts for public sector workers had become acrimonious. A time-out was necessary. The IMF mission—as the teams of economists it sends around the world are called—had supposedly even left the country for few days to allow tempers to cool. The press ran stories that the IMF and officials of the European Community were in sharp disagreement as to whether Greece, even if it submitted to these cuts, would be able to climb out of its economic hole. The IMF had begun to recommend that some portion of the loans made to Greece by other European governments be written off. The European authorities were said to be resisting such a move.

Despite the glass atrium, many of the conference rooms are claustrophobic with no natural light, so mission teams often convene impromptu meetings in the coffee shop.

During the same period, Christine Lagarde paid a well-publicised visit to Cairo, setting the stage for a resumption of discussions between the IMF and the then newly installed civilian government. Negotiations over a potential loan to Egypt had been suspended earlier in the year by the country's military, which had taken bitter exception to some of the IMF's conditions.

Meanwhile in Buenos Aires, the authorities were suspected to have been fiddling their inflation numbers. In early September, the Fund announced that it had imposed a deadline for the Argentine government to improve its economic reporting. The IMF board gave them three months to rectify the situation or risk censure and possibly even suspension. While such a move would not

be unprecedented—Zimbabwe had been suspended back in 2003—this would have been a deep humiliation for Argentina.

As fears of a sovereign debt meltdown spread across Europe, the European Central Bank announced that it was prepared to buy the government bonds of those countries in trouble—provided, crucially, that these countries enter into IMF-supervised economic programmes to stabilise their finances. But no one seemed to be sure just what these programmes entailed. Most observers believed this would thrust the Fund into a central role in the effort to stabilise the Euro. However some commentators agonised that rather than giving the Fund more influence over the economic policies of troubled European countries, this would turn it into a rubber stamp for the ECB.

As if this was not enough, the world press latched onto an IMF report towards the end of September that the financial system remained dangerously unsafe, three years after the global crisis had almost brought it down. Despite reform attempts on both sides of the Atlantic, many of the same factors that had caused the whole system to seize up continued to be a threat. All these events could be gleaned from the major business papers. But had we dug a little deeper, we would have discovered that these were just the most visible signs of a much bigger imprint that the IMF makes on world affairs.

Throughout September, all eyes were on two high-profile Fund missions to Greece and Portugal. The Fund had just committed to the two largest loans in its history to these countries, totalling some $72 billion a figure on which the future of Europe's economy might hang. But for the 188,000 citizens of Sao Tomé and Principe, a tiny Portuguese-speaking island nation off the coast of West Africa, their principal concern was the IMF mission that had arrived in their country on September 14th. In July, the Fund had extended a loan of $4 million to the island nation. The main task of the mission was now to help prepare the 2013 budget and assess progress in clearing the debts that had accumulated between the Treasury and the state-owned water and electricity company.

In Ulan Bator, the capital of Mongolia, another IMF team landed. Three years previously, the landlocked Central Asian country had been on the verge of collapse as the price of its prime export, copper, crashed, sending the domestic banking system reeling. With some assistance from the IMF, the country had avoided a bank run. A couple of fortunate large-scale mining projects enabled a dramatic recovery. By 2012, it had become one of the world's fastest growing economies

and the Fund team now focused on the opposite problem: the dangers posed by an overheating economy.

On the other side of the world, an IMF mission arrived in Mbabane, the capital of Swaziland, where public expenditures had run amok, the government could not pay its suppliers, unpaid bills mounted and a fiscal crisis loomed—unless something was done.

That same month, missions rolled into Yerevan, the capital of Armenia; Tirana, the capital of Albania; Ouagadougou, the capital of Burkina Faso; and Sofia, the capital of Bulgaria. Three separate missions arrived in Belgrade, Zagreb and Ljubljana, once Yugoslav cities and now the capitals of Serbia, Croatia and Slovenia respectively. A mission had been dispatched to Dominica, one of the tiny islands

The IMF only began to lend significant amounts during the 1970s, when the UK and Italy fell upon hard times after the first oil shock and had to borrow $4.5 billion dollars.

in the Caribbean, not to be confused with the Dominican Republic, where it so happens a mission also arrived. In Dominica the team aimed to help the government deal with a grave slowdown in growth following the outbreak of banana-leaf disease. In the Dominican Republic the primary focus was on the fiscal position, which had deteriorated, despite the sale of the biggest brewery in the country to Anheuser-Busch's Brazilian subsidiary.

The IMF's missions are not always welcomed, though they generally have to be tolerated. Also in September, IMF teams arrived in Pakistan and Jamaica, both countries with long and contentious histories with the Fund, where the organisation is viewed with deep suspicion, relations with authorities can be fractious, and the proceedings often tense.

During that long September, altogether twenty-eight different missions were dispatched to look over the shoulders of the central bankers and Ministers of Finance of such diverse countries as Honduras and Australia, The Gambia and Nepal, Senegal and Cambodia, Liberia and Kenya, The Ivory Coast, Tanzania and Sierra Leone. In addition to these much publicised visits, involving the various governments' highest economic officials, scores of lower-profile teams arrived in the capitals of some of the world's poorest countries to help reform tax systems, improve budgeting procedures, clean out the bad loans in their banks, collect statistics on money supply, and sort out investment policy for foreign exchange reserves.

A

As the global economy teetered on the edge of disaster for the third time in four years, one might imagine that the IMF headquarters in Washington DC, two elegant but carefully anonymous buildings, just three blocks from the White House, would be the scene of frenetic bustle: harried-looking senior officials rushing around surrounded by aides, double-parked banks of black town cars blocking traffic, packs of photographers and TV crew loitering on the sidewalk. Not so. When I showed up that beautiful early September day, all was quiet. A few smokers, several of them Japanese, along with one young Indian man, had snuck out of the building for a mid-morning cigarette. There were no beleaguered finance ministers, no limousines nor reporters in sight. Just a few sober-looking people carrying briefcases going about their everyday business.

The entrance opened into a large glass atrium, reminiscent of a 1970s Hyatt, without the crowds or the music or the plants. A grand staircase led up to the mezzanine floor. A few young men and women were milling around. Some of the men were wearing ties, most not.

A large split-screen TV carried CNN news reports on one side, and on the other, a scrolling calendar of upcoming events: seminars on "Financial Deepening and Economic Instability" and "Economic Growth in Japan"; one with the lengthy title, "Inter-Sectoral Knowledge Linkages, Technology Compositions and Income Differences", which left me rather foxed. There were the usual marks of corporate social life: Weight Watchers meetings

every Monday lunchtime, an evening devoted to "Choosing Independent Schools in Washington", an evening of German cuisine in celebration of Oktoberfest. Beginner Ballroom dance classes were on Tuesday evenings, while Thursdays alternated between Merengue and Rhumba lessons and Tango practice. A couple of months later Bollywood dancing would be added to the schedule.

In contrast to when I first visited the Fund in 1978, security at the entrance was exceptionally tight. Guests had to be met at reception by a staff member and escorted wherever they go in the building. Visitors are therefore rare—perhaps some economists from the Federal Reserve Board down the road, or from one of the countless Washington think tanks; Chinese students being taken on a tour. The place had the insular feel of a suburban office park.

Except, that is, for the flags. Above the entrance hung the banners of the Fund's 188 member countries. And, of course, for the people. That day like any other, the staff gathered in the coffee shop, the Bistro, or up on the mezzanine terrace for their mid-morning caffeine fix. One glance told me that this was not the typical American corporation that you would find in the average suburban office complex. The 2500 people who work here come from 150 different countries. Americans account for about one in six; the next largest group are the British (145) followed by Indians (133), French (121), Chinese (109) and Germans (104).

The Bistro is the social centre of the building. Here a desk officer who needs to clear his head after working all morning on the interlocked spreadsheets of the monetary system of a waterlogged African republic, or an economist suffering from cabin fever after days holed up in his office writing a paper on the causes of inflation in South Asia, can take a break and gather to gossip. Despite the glass atrium, many of the conference rooms are claustrophobic with no natural light, so mission teams often convene impromptu meetings in the coffee shop.

Over half of the professional staff are economists. While most people view economists as a particularly argumentative lot, their reputation for squabbling is greatly exaggerated. The sorts of economists who come to the IMF tend to identify with its approach and goals; this is not an organisation beset by internal disputes. People seem to agree about much more than they disagree.

Almost a third of the staff is European and with the IMF so deeply involved in lending to their rattled continent, there was much dis-

27

cussion of the Euro. At one table two young men were hammering out the Greek issue, the German lamenting his own country's policy. This is an organisation where people check their passports at the door. At the next table a long debate about the consequences of fiscal austerity was taking place. The Research Department had circulated the draft of a paper suggesting that the costs of retrenchment have been greatly underestimated. This was causing a buzz throughout the organisation and some alarm in certain quarters. At another table a few researchers were talking about Kalman filters and latent variables.

T

The IMF was created at the tail end of the Second World War at a conference held in Bretton Woods, New Hampshire, attended by 750 delegates from forty-four countries. Out of this meeting emerged two new institutions, the World Bank and the International Monetary Fund. These two "sister" organisations are often confused one with another. They do however have distinct purposes, though they remain joined at the hip with the same body of shareholders, a similarly composed Board of Governors, and facing locations on opposite sides of 19th Street in Washington.

The World Bank, whose official name is the International Bank for Reconstruction and Development, was created to channel capital to war-ravaged countries but has since evolved into an institution that makes long-term loans and grants to the world's poorer nations for development projects. The IMF was supposed to oversee the rehabilitation of the international financial system, which had collapsed during the 1930s. It too has seen its mission transformed.

The Fund was the joint brainchild of two men: Harry Dexter White, then an Assistant Secretary of the U.S. Treasury, and John Maynard Keynes, then chief economic adviser to the wartime British government. Their singular purpose was to avoid a repetition of the international economic chaos of the inter-war period, when countries out of desperation had resorted to beggar-thy-neighbour policies at the expense of their trading partners.

White held that the key problem was that the international monetary system was not governed by any rules and lacked a referee. He sought to create an institution with a dual purpose: an international credit cooperative to make short-term loans to countries in

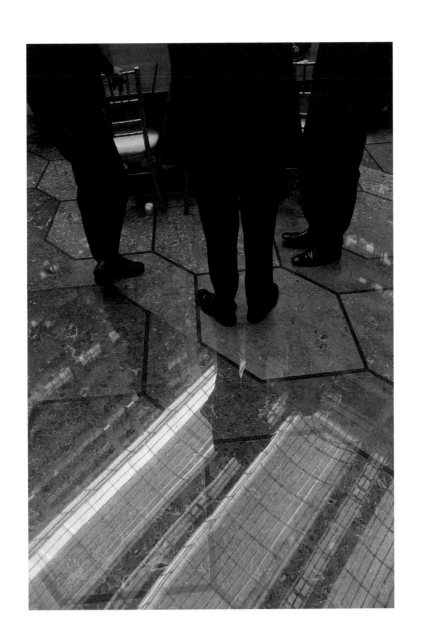

financial distress, to carry them over their immediate difficulties; and a referee to regulate what countries did with their currencies and thus to prevent the sort of destructive international competition that wrought such havoc in the 1930s. He believed that exchange rates had to be politically controlled. If a country wanted to alter the international price of its currency it could only do so with permission from the IMF.

Though sharing much of White's vision, Keynes had a much more ambitious conception. He believed that the central problem of the interwar years had been the lack of enough international money to grease the wheels of commerce, which had in its turn forced excessive austerity upon countries such as the UK and Germany and resulted

Washington institutions are often accused of being excessively self-obsessed, too caught up in their own partisan squabbles. It is reassuring to find an organisation in the city whose eyes are resolutely fixed on the wider world.

in terrible mass unemployment. He wanted something akin to a World Central Bank that would become the principal source of international money.

None of these objectives have been brought to pass. While the Fund's involvement in the economic affairs of many countries, particularly the smaller and poorer ones, has gone much further than its founders could have imagined, it is much less powerful than they hoped. There are some extreme right-wing conspiracy theories circulating on the internet, which cast the Fund as part of an international cabal of bankers and politicians intent on establishing a secret world government. One such fantasy has it that the IMF and World Bank are owned

by the Rothschilds and thirty to forty of the wealthiest people on the planet, who have embarked on a project to force countries to liquidate their assets in a fire sale, enabling this secret group of plutocrats to take over the world. Another, even more comical, fantasy is that the IMF is part of the Committee of 300, an organisation bent on ruling the world, run by the Illuminati, a secret society like the Freemasons established in Germany in the 18th century, which also includes the National and World Council of Churches, the Hongkong and Shanghai Bank, the Vatican—and most improbably, the Yale undergraduate society, Skull and Bones. The reality is much more prosaic. The IMF has never been, nor is likely to become, a global central bank, though it did play an important role in regulating when and how countries should change their exchange rates back when currency values were fixed during the 1950s and 1960s. Even that modest role became redundant when the world's major countries began to float their exchange rates in the early 1970s.

What has remained is the IMF's role as an international credit union for countries—it is now most famous for the loans it makes. During its first couple of decades, when the Fund was focused primarily on policing international exchange rates, its lending was marginal. Western Europe was being reconstructed after the ravages of the war and it was there where it concentrated its money. Its first loan was all of $2.5 million to France in 1947. Even adjusting for inflation, this was a minuscule sum.

The IMF only began to lend significant amounts during the 1970s, when the UK and Italy fell upon hard times after the first oil shock and had to borrow $4.5 billion. Since then its loans have ebbed and flowed with the fortunes of the global economy, rising in times of crisis and receding as panic subsides. As the scope and severity of financial crises keeps growing, the waves get progressively higher. At its peak, lending in the mid-1980s reached close to $30 billion. The next peak, in the late 1990s, touched $50 billion. Right now it has reached $200 billion and has yet to top out.

As each decade brings its signature financial crisis, the identity of the major borrowers keeps changing. In the 1970s, the two largest were the UK and Italy. In the 1980s it was the Latin Americans who, having run up unmanageable bank debts in the 1970s, had to turn to the Fund when they could no longer service these debts. In the early 1990s, it was the East European countries emerging from the Soviet shadow; in the late 1990s it was the seemingly bright economies of

Asia, which ran into the problem of too much short-term debt.

The misleading lull of the mid-2000s induced some profound soul-searching. For a brief period, central bankers convinced themselves that financial crises were a thing of the past. The world was booming. Rich countries had long stopped borrowing from the Fund. Emerging markets, as successfully developing countries were now called, had improved the ways they managed their economies and seemed to have broken free of the cycle of recurring busts. For the Fund, which essentially thrives on such crises, these were difficult years. Everyone started asking themselves fundamental questions about the Fund's role: what it should do, and why or whether it should be kept alive.

And then the crisis of 2008 hit. The interlude of the mid-2000s was simply the calm before the storm. Not only did financial instability still exist in developing countries, it also rocked wealthy developed nations. The tale has come full circle, so that the Fund's largest borrowers are once again European countries, notably Greece, Portugal and Ireland.

So where does all the money for the IMF's loans come from? The Fund's finances are unusually arcane, involving a complicated system of book entry credits and debits in many different currencies—some of which can be readily used, others not—between the balance sheet of the organisation itself and the central banks of the world. I found that even people who work there are often hard-pressed to explain the accounts. But stripped of unnecessary mystery, the essence is this: each of the members makes a deposit into the Fund based on a complicated formula, which tries to measure its relative weight and participation in the global economy; that money, currently amounting to some $350 billion, then becomes available for loans to member countries facing temporary financial difficulties. In addition the Fund has lined up a further $550 billion in lines of credit directly from some of the wealthier governments, which gives it not too far off a trillion dollars to play with.

This sounds like a lot of money. But the world's financial system has grown so large over the last three decades as to dwarf even a trillion dollars. For example, when the Fund was created in 1945, it was almost twice the size of the largest bank in the United States, at the time the Bank of America. By contrast today, even with its trillion dollars, the IMF is less than half the size of the largest US bank, which is currently J.P. Morgan. As a consequence, its ability to rescue any of the larger economies in the way it could in the mid-

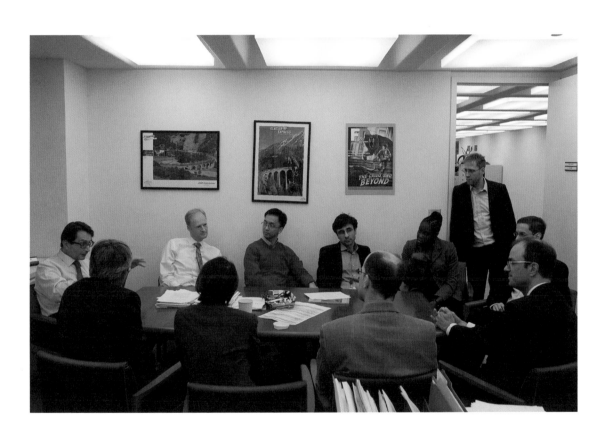

1970s is limited. Over the last thirty years its money has served primarily to help smaller and poorer countries.

When the IMF opened its doors in 1945 it had twenty-nine members. While delegations from forty-four countries showed up at Bretton Woods, once the Cold War began all of the Eastern bloc states refused to join, viewing it as simply a tool for Western bankers. But since the collapse of communism in 1990 all of these former Soviet bloc countries have come on board. Almost every member of the United Nations belongs to the IMF. There remain two archaically Communist holdouts: North Korea and Cuba. Others who are not members are either the truly rich—Monaco, income per capita $186,000, or Lichtenstein, income per capita $141,000—or the very small, Niue (population 1400), Nauru (population 9,400) or the Cook Islands (population 19,000), though recently Tuvalu, a South Pacific island with a population of just 11,000, did join.

In the planning stages everyone assumed that Harry Dexter White would be the first head of the IMF—including White himself. He was one of its chief architects, and it made sense to put an American atop what was to be the centrepiece of a dollar-dominated global financial system. But in the months before the Fund opened its doors, the FBI revealed to President Truman that White was suspected of being part of a Soviet spy ring. To avoid the embarrassment that such a revelation would cause, the Administration quietly dropped White's nomination and instead went along with the suggestion that the Belgian Camille Gut be the first Managing Director. This decision set the precedent that endures today, that the Fund should be headed by a European. In fact, as the French seem to have a ward heeler's ability to round up the votes of their fellow Europeans, five of the last eight Managing Directors have hailed from France.

The Fund's Washington location was however very much White's doing. Keynes wanted to place it in London, in the hope of restoring the City's claim after the war to be the world's premier financial centre. But the American, who after all was a communist, deeply suspicious of bankers of any nationality, pressed the case for Washington. Back then the capital of the United States was still a sleepy Southern town.

While the IMF has been in Washington for nearly seventy years, it has never really become part of the city. The local press corps does not pay much attention to it. Although this is a city teeming with reporters who revel in the minutiae of government, who can describe

in wonky detail which committees on the Hill are reporting this week's bills, for some reason—perhaps because the IMF has most of its impact on small countries outside the United States—if you quiz the average Washington correspondent about how the IMF loan to Egypt is proceeding, or whether the revisions to the Irish program are well in hand, all you get is a blank stare. Most would even struggle to tell you exactly where the organisation's head offices are.

By the same token, Washington does not figure much in the institutional life of the IMF. Apart from the World Bank across the street—and maybe occasionally the Fed—most staff have few dealings with local organisations.

One of the most famous *New Yorker* covers is Saul Steinberg's illustration of *A New Yorker's View of the World* which depicts an exaggeratedly foreshortened picture of the world, with an oversized Upper West side of Manhattan at the centre and the rest of the country, and indeed the world, as the suburbs of the city. The world as seen from the IMF would look exactly the opposite. Countries in financial trouble around the globe—Greece, Ireland and Portugal in Europe, some of the big potential borrowers in South America such as Mexico and Brazil, all too much of Africa—would be exaggerated in size. The US would contract to three lone buildings in Washington: the Treasury, the Fed, and the World Bank. There would be no White House and no Congress. Washington institutions are often accused of being excessively self-obsessed, too caught up in their own partisan squabbles. It is reassuring to find an organisation in the city whose eyes are resolutely fixed on the wider world.

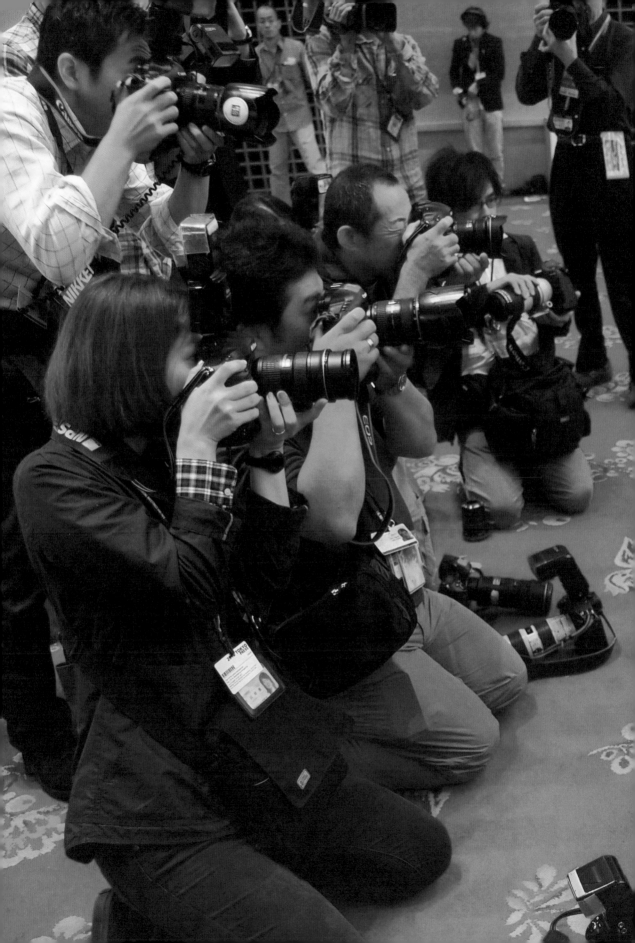

Tokyo

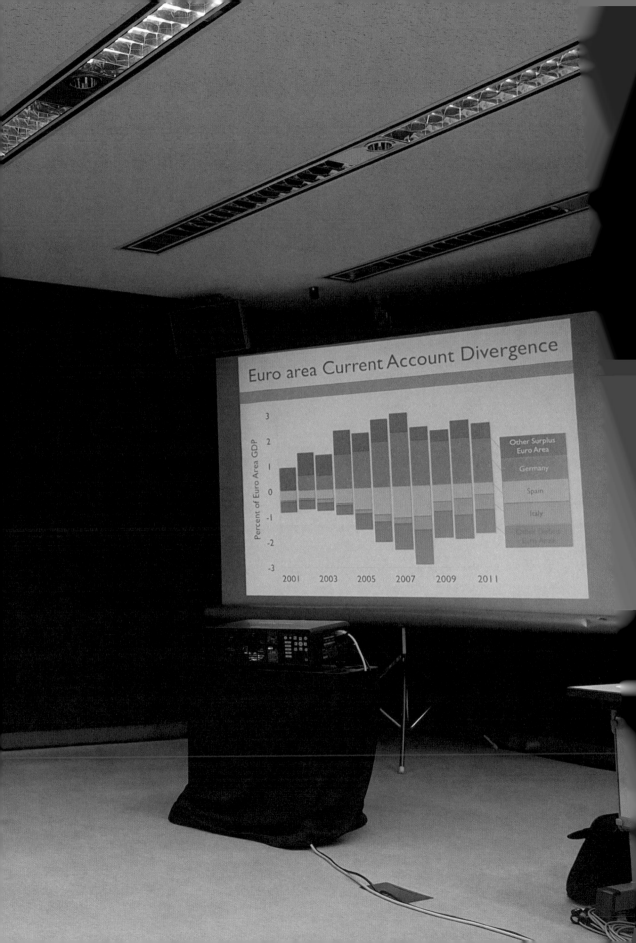

MARÍA ANGÉLICA ARBELÁEZ
COLOMBIA

For the world's bankers and financiers, it is not April that is the cruelest month, but September. For this is the month when most financial crises hit and the world's stock markets have their most serious tumbles. Why this should be so remains one of the mysteries of economics. During the 19th and 20th centuries it was thought that the pattern could be caused by the crop seasons. Farmers and merchants would borrow heavily in the fall to bring in the harvest, imposing in their turn a strain on the cash position of banks and making the whole financial system temporarily vulnerable. But over the last century, even as agriculture has declined dramatically in significance, this seasonal spike in crises has continued. A disproportionate number of panics—more than a half—occur in the period from late August through to September. Almost three quarters take place sometime in the fall.

Perhaps it has to do with the end of the vacation season: all those well-heeled bankers, returning to work after the hazy days of summer; the Europeans back from their hallowed August vacations in Provence or the Côte d'Azur; Wall Streeters heading home from Nantucket or Sun Valley, Idaho, jolted back into reality.

Whatever the cause, this also happens to be the time of year when the IMF and the World Bank hold their joint annual meeting. As a result, as the annual meetings are about to begin, there always seems to be a sense of dread hanging in the air. Too many participants can recall past Septembers when they have gathered against the backdrop of a global financial crisis: 1976, when Dennis Healey, the British Chancellor of the Exchequer, was forced at the last moment to turn back from the airport on his way to Washington to head off a collapse of the pound; 1979, when Paul Volcker had to rush back from the Belgrade meetings to deal with a free-falling dollar; 1982, when Mexico defaulted on its bank debts just before the Toronto meetings, which had been brought

Liaquat Ahamed

forward a few weeks to adjust for Eid, the Islamic holiday; 1998, when the implosion of the hedge fund, Long Term Capital Management, threatened Wall Street; and 2008, when Lehman Brothers folded while the whole world looked on.

And so it was this year as I, and 12,000 other participants, prepared to attend the Tokyo meetings. The *crise du jour* this time was over the Greek situation. Just as the meetings were getting started, missions from the IMF, the European Central Bank and the European Commission were descending on Athens to try to lay out an agreement on the third write-down of Greek debt. Everyone recognised that were the Greeks to walk away from the negotiations, in effect declaring national bankruptcy, we would have had another, even larger Lehman on our hands.

The meetings are part convention, part talk fest. The main ceremonial event, at which the Managing Director of the IMF and the President of the World Bank deliver an annual report to the 370-odd finance ministers and heads of central banks who make up the Board of Governors and their Alternates, lasts barely a couple of hours. The other official event, the convening of the International Monetary and Financial Committee, a group of twenty-four finance ministers that acts as the steering body of the Board of Governors, takes up one afternoon. Very few of the 12,000 people who turn up for the annual meeting are invited to either event. Nor do they care. They come to network, to meet their peers, to catch up on gossip, to make deals, hold high-level talks, attend seminars and symposia, conduct press conferences, and of course, go to parties.

The meetings are held two out of every three years in Washington. For a week the streets downtown by the IMF offices near the White House are clogged with town cars, limousines and police barricades. But every third year the show is taken on the road.

In 2000 the spectacle was staged in Prague, in 2003 in Dubai, in 2006 Singapore. Three years ago it turned up in Istanbul. In 2012 it was scheduled to be held in Sharm-el-Sheikh, but after the overthrow of the Mubarak regime and the souring of the Arab Spring, security conditions in Egypt made that a no-go. The Japanese government came to the rescue and despite the short notice offered to host the meeting in Tokyo, which provided the country with an opportunity to showcase their recovery from the terrible quake and tsunami of 2011.

At its very beginnings immediately after the Second World War, the group that met—composed only of senior officials from the orig-

inal twenty-nine members—functioned as a sort of conclave of the cardinals of capitalism, intent on rebuilding the Western financial system after thirty years of war and depression. Even then, the annual meetings were grand affairs. Many of the financial statesmen of the era had either been bankers at the tail-end of the Gilded Age or, in the case of the British, colonial administrators. They were used to a certain style of doing things. When they met in London in 1947, the Fund staff and the US delegation crossed the Atlantic on the largest and most luxurious liner of the day, the *Queen Elizabeth*.

By the late 1950s, when membership had grown to sixty-eight and a more inclusive, levelling tendency was beginning to creep in, several hundred officials turned up. But while central bankers and treasury mandarins like to aim for a certain low-key anonymity, it is hard to collect a couple of hundred finance ministers and their deputies, who

What has truly changed the character of the annual meetings is the vast caravan of camp followers and hangers-on that now turn up

have spent their careers jockeying for influence and media attention, without making something of an event of it. In 1958 when the assembly met in New Delhi, the host government assigned 120 official cars to taxi the now several hundred delegates.

Since then, membership has swollen to 188, and the number of actual delegates to 3000. Not surprisingly the largest delegations come from the most powerful countries. Not counting the attendees from the huge US embassy in Tokyo, some 85 delegates flew over from the US, most of them from the Treasury Department or the Federal Reserve, a handful from the State Department, but more than a handful of special agents from the Department of Homeland Security, presumably all on security details of one sort or another. The Germans were very much in evidence, a reflection of their newfound status as the financial masters of Europe. There were also some odd anomalies in

Liaquat Ahamed

delegation size. The Brazilians have always sent large parties, and this year some 73 were in attendance. Likewise the Saudis. I noticed many Africans, and not simply because 44 out of the 188 member countries are from that continent—their delegations tend to be unusually large. The Nigerians sent close to 70 delegates; the Democratic Republic of the Congo almost 20. By contrast the Indians, who are now among the top 10 countries in terms of economic clout at the IMF, with an economy close to 100 times the size that of the Congo, sent only 13 representatives. Even the Most Serene Republic of San Marino, the microstate nestled in the Apennine Mountains with a population of 30,000 and a GDP that barely breaks $1 billion, sent 9 envoys to guard its interests.

What has truly changed the character of the annual meetings is the vast caravan of camp followers and hangers-on that now turn up: commercial and investment bankers, market analysts, portfolio and hedge fund managers, think-tank intellectuals, heads of NGOs, and even social activists, who not so long ago were among the fiercest critics of the Bank and the Fund, but who now find themselves drawn into the fold.

Finally over 1,500 journalists were in attendance. Though about a thousand of these were local, the remainder had come in from all around the world. All the big business wire houses—Reuters, Bloomberg, Dow Jones—were well-represented. And while neither *The New York Times* nor the *The Washington Post* had bothered to send correspondents, the editors of some unusually obscure publications—the *Phnom Penh Post*, the *Yangon Times*, *New Business Ethiopia*, the *Nepali Times*, *Infomarket* of Moldova and the *Sudan Business Weekly*—had found their way. Two of the most active interviewers at the press conferences came from Sri Lanka and the Côte d'Ivoire. And it turns out that Nigerian journalists like to travel as much as their financial officials, for there were close to twenty on hand.

Everyone's status could be identified by the colour of the badges worn around their necks. The top Pooh-Bahs, the Governors of the IMF, flashed navy blue cards; country delegations wore green, special guests gold, the Press yellow, Fund staff light blue, visitors (all those hundreds of bankers, economists and analysts milling around) red, representatives of what is called "civil society", pink. Unlike the World Economic Forum at Davos where a rigid hierarchy operates and one's first reaction on meeting someone is to scan the colour of their card, in Tokyo—likely because the system was so elaborate,

Liaquat Ahamed

and no one could remember what the colours meant—the only people who cared were the officiously vigilant Japanese security.

The men were uniformly dressed in dark suits and ties, apart, that is, from two groups: the Iranians, who have an odd habit of buttoning up their collars but refusing to wear ties, and the hedge fund managers, who were young, fit and wore designer suits. The hedge fund managers no doubt refused to wear ties for much the same reason as the Iranians—to signal their rather self-conscious freedom from arbitrary social conventions. Though the Iranians kept to themselves, they were a cheerful bunch, taking numerous photos of each other.

Most women were dressed in the feminine equivalent of serious business attire, except for some of the Africans, who came in long colourful skirts and bright head-wraps. The Fund's Managing Director herself, Mme. Lagarde, wore elegant designer dresses, appearing on

As Walter Wriston, head of Citibank, and the most prominent commercial banker, once observed, "Countries don't go bankrupt."

the first day's press conference in a bright blue outfit by Issey Miyake, a nod to her Japanese hosts. During the plenary session, in her white Christian Dior dress and with her white hair, she cut a striking figure surrounded by this sea of men, gravely suited in black and blue.

Most events took place at the Tokyo International Forum, a giant conference centre that resembles an ocean liner, beached in the heart of the Marunouchi, the traditional commercial district that lies between Tokyo Station and the Imperial Palace. The really important delegates—the most senior Americans, Germans, French and British—had rooms at the Imperial Hotel, as did the top officials of the Fund. The bankers stayed at the Peninsula, the Four Seasons or the reconstructed Palace Hotel, where rooms went for $800 a night. The remainder of visitors were dispersed throughout the city. The Indians, Irish and Pakistanis stayed at the New Otani, an enormous and bland hotel in Akasaka. The delegates from several of the East

and Southern African countries—Swaziland, Botswana and Tanzania—
as well as the Cypriots, stayed slightly further out of town, at the
Intercontinental located on the reclaimed area of Tokyo Bay.

A bus service shuttled delegates from the hotels to the conference
venue, departing precisely on schedule, as per the Japanese way. A cab
ride from the outlying hotels to the Tokyo International Forum could
cost around $20, so the punctual shuttle was heavily patronised, and
was a good place to strike up conversations. Everyone commented
on the high standard of living apparent in Japan. If this is what a
"lost decade" looks like, if Japan is a harbinger of what the Western
economies can look forward to, then the future may not be so bleak,
remarked the economists. Everyone complained about the cost of
living: a dinner for two at the Japanese restaurant in the Imperial set
you back $500, a couple of glasses of wine, $100.

D

During the 1950s and 1960s, these meetings were pretty much restrict-
ed to a few heavy hitters from the big powers, who spent their time
grappling with the thorny issues on the lofty reaches of global finance.
Whether, and if so for how long, the US would be able to maintain its
peg against gold; whether the price of gold would be adjusted upwards;
how the new and experimental international currency known as
Special Drawing Rights should be constituted. These were issues for
economic statesmen, way above the pay grade of the average commercial
banker, even investment banker, concerned with the prosaic business
of making loans, cutting deals and turning a profit.

It was during the 1970s that the world's commercial bankers
started to attend. They suddenly found themselves awash with mon-
ey deposited by the newly enriched oil sheikhs. Faced with stagnant
economies at home, they set off in pursuit of new lending opportunities
and stumbled across the benefits of lending to less developed nations.
As Walter Wriston, head of Citibank, and the most prominent
commercial banker, once observed, "Countries don't go bankrupt."
Major bankers, who were pumping tens of billions of dollars in loans
to countries in South America and East Asia, realised that at these
meetings they could find all their biggest clients in one place.

By the mid-1970s the gatherings had been transformed into a sales
convention for global bankers. If you were Walter Wriston or David

Rockefeller of Chase Manhattan, you could have breakfast with the finance minister of Brazil, a mid-morning meeting with the finance minister of the Philippines, followed by lunch with the governor of the central bank of Turkey, an afternoon of strategy with your senior regional vice presidents from around the globe, topped off with a cocktail party for the finance ministers of Central America. All this without having to fly multiple times around the world and contend with days of jet lag.

In 1982 it looked as if the party might be brought to an abrupt halt. Several of the largest borrowers, Brazil, Mexico, and Argentina, found it increasingly difficult to drum up the cash to service their loans. And while Wriston was right that countries don't actually go bankrupt and close shop, they can choose to stop paying their bankers. Nor was this the Gilded Age, when the British or Americans could resort to gunboat diplomacy, sending in the Marines to recover loans from deadbeat countries; today's world might frown upon such actions. In 1982, there was very little that bankers could actually do. Their dilemma was that so large were their loans, especially to Latin America, that if they tried to write them off, they themselves would have been driven into bankruptcy.

The IMF stepped in to save the Western financial system, by lending enough to the major debtors to keep them current on their payments. Nevertheless the governments that ultimately control the Fund did not want to inject money into debtor countries just to pay off bank loans. The Fund therefore insisted that it would only lend if the banks did not pull out, and had to at least keep their existing loans in place. Thus for the next few years, the Fund, the large money-centre banks and the super-debtors found themselves locked in an increasingly uncomfortable embrace. They all needed each other. The banks needed the Fund to inject enough new cash so that the countries could at least appear to be meeting the interest on their loans. The Fund needed the banks not to call in their loans so that it could claim to be saving countries from economic collapse rather than bankers from the folly of their mistakes. The Fund and the bankers alike needed the countries to play along with the charade and not to default. For several years the annual meetings became very tense affairs, with much triangular horse-trading going on between the parties.

Although the Fund channelled some $24 billion into countries with debt problems, it was often accused during this period of being on the side of the big foreign banks, and came to be seen by the man

in the street as a collection agency for bankers. Eventually however, the banks agreed to write off some of their debts to Latin American countries as uncollectible, and everything was more or less sorted out, although it took close to a decade. In the 1930s a similar debt crisis in the less-developed world, without an IMF to smooth the way, had driven international bankers to abandon business with developing countries for almost fifty years. This time around the system was much more resilient. Once the developing country debt crisis of the 1980s had been resolved, international bankers picked themselves up from the floor and went back to business.

But it was not all smooth sailing. International banking as a whole remained fraught with peril. In the nineties, the South East Asian countries—Thailand, Indonesia, the Philippines and Korea—long a source of profits for banks, got themselves into temporary difficulties. In 1998, the Russians played the bankers for suckers and cynically walked away from their debts, despite the fact that everyone knew that Russian oligarchs had stashed away billions of dollars in Swiss bank accounts. The Argentines, who have made defaulting on their debts almost a way of life, having done so seven times since their independence in 1816, stopped paying once again in 2002. However, the bankers were making enough money from loans to Eastern Europe, from deals in Kazakhstan and Uzbekistan, and from joint ventures in Mexico and Brazil, that overall these were good times.

They discovered, moreover, that they did not just have to make loans and keep risking their own money in such large amounts. They could help countries borrow from other people by selling bonds to the wider public, or by arranging for the privatisation of state-owned enterprises such as power plants, refineries and fertiliser companies.

With the arrival of the bankers, the annual meetings became even more glittering affairs. They gave grand parties. In Washington, they would take over the Corcoran gallery, or the Air and Space Museum, or put up a tent on the Mall, or rent out the Phillips Gallery, where guests could dine surrounded by Impressionist masterpieces.

I remember one such event in the early 1980s at the Corcoran, hosted by a bank then on the rise and now long gone, swallowed up in one of the last couple of decades' innumerable takeover battles: a theme party based around the Orient Express. The food stations scattered over the main floor offered finger delicacies from every city through which the Express passed, something from Paris, and

from Strasbourg, from Munich and Vienna, from Bucharest and Belgrade and Budapest, from Sofia and Istanbul, topped off with a giant ice cream mountain modelled on the Alps. The international spread suited the cultural diversity of the guests.

We used to joke that the best way to figure out in advance which bank was about to get into trouble was to identify which had hosted that year's most over-the-top party. There was a certain logic to this rule. The same hubris that caused banks to make bad investments or loans could seduce them into hosting the most extravagantly wasteful affairs.

In the 1990s, the whole tone of the meetings began to change.

The 2500 people who work here come from 150 different countries. Americans account for about one in six; the next largest group are the British (145) followed by Indians (133), French (121), Chinese (109) and Germans (104).

It started with the anti-globalisation demonstrations at the IMF and World Bank's fiftieth anniversary celebrations in Madrid in 1994. Bankers found their parties disrupted by noisy demonstrators. At the plenary session, Greenpeace activists showered the attendees with fake dollar bills. Thereafter protesters became a fixture of the annual meetings, and the bankers even stopped attending for a while. They discovered the World Economic Forum at Davos, a place to see and be seen, where parties were not frowned on but served as the currency of influence, where the snow and cold weather and Swiss police and private security firms kept demonstrators at bay.

The bankers are now back but the meetings have become more staid affairs. One is much more likely to be invited to a serious economics

Liaquat Ahamed

symposium than to a glamorous caviar reception. The World Bank and IMF host a sequence of seminars on such topics as "Restoring Public Debt Sustainability in a High-Risk Environment", "Policy Options for Jobs and Growth" or the "Energy Challenges of Africa". The banks offer similarly worthy programmes. Deutsche Bank hosted a 90-minute event on "The Eurozone and Japan: The Way Forward." J.P. Morgan runs an Emerging Markets Investors Conference, an all-day power-point-laden battery of presentations by its army of emerging markets analysts on such topics as banking in India, the rise of consumer-durable spending in Asia, or perhaps the prospects for aluminium companies in Africa.

Since the 2008 crisis, a certain friction seems to have developed between the IMF and the bankers. It has not yet broken into outright conflict or antagonism but relations are clearly not harmonious. The main bone of contention lies in bank regulation. On the Wednesday of the October gathering, the Fund held a press conference to unveil its biennial Global Financial Stability Report, which argued that despite efforts at greater regulation, the financial system is no safer than before the storm in 2008. This set off a stir in many different circles, both among regulators who thought that they were not being given enough credit for what they had accomplished and bankers instinctively resistant to demands for further regulation.

The centre of gravity of opposition to this call for further stringency is the Institute of International Finance (IIF). Formed in 1982 after the debt crisis to coordinate the response of the big global banks to international problems, it has become the banks' lobbying organisation and now holds its annual meeting at the same time and place as the Fund gatherings, as a sort of parallel conference.

In Tokyo the IIF meeting was held at the newly opened Palace Hotel, a flashier and more expensive setting at the other end of the Imperial Palace Gardens than the Okura and the Imperial where the IMF is based. The crowd was equally contrasting. The IMF meetings were mostly peopled by mid-level officials of finance ministries and central banks from around the world in ill-fitting suits made by their local tailors, while at the Palace Hotel the bankers could be effortlessly identified by their well-tailored Zegna suits and Hermes ties.

The CEOs of the world's biggest banks are all on the board of the IIF and most turned up for the Tokyo annual meetings. Conspicuously absent, however, was Jamie Dimon of J.P. Morgan. At the Washington meetings in 2011, he had a heated contretemps

over bank capital requirements with Mark Carney, the Governor of the Bank of Canada and head of the Financial Stability Board, the nearest thing to a global watchdog. Dimon's tirade against excessive government regulation came back to bite him this year when he was forced to announce some very large losses from the investments by J.P. Morgan's London office in complicated credit derivatives.

<p align="center">T</p>

Though the parties were more subdued than a decade ago, there were still many receptions, hosted by all sorts of obscure institutions. One night I stumbled half by mistake into a cocktail party jointly hosted by the Macroeconomic and Financial Management Institute of Eastern and Southern Africa and the Crown Agents. I had heard of the Crown Agents, but thought that they had long disappeared. Once upon a time, during the 19th century, they managed the financial affairs of all the various territories, crown colonies, protectorates and dependencies that made up the British Empire: in other words, a quarter of the world. Now they function as a sort of development consultant.

60

One evening a friend dragged me to a reception hosted by the Institute for International Monetary Affairs, a Japanese think tank run by the legendary Toyoo Gyohten, one of the grand old men of Japanese finance, best described as the Japanese version of American economist Paul Volcker. Another evening we were confronted by a wide range of choices for entertainment: a reception hosted by the Lebanese banks at the Peninsula; another by the Association of Qatari banks at the Mandarin Oriental; alternatively should we possess the stamina, the Institute of International Finance was celebrating its thirtieth anniversary with a big reception and dinner at the Tokyo Prince Hotel, where the keynote speaker was to be Masaaki Shirakawa, Governor of the Bank of Japan. In the end we gave that a miss.

Generally, the elite investment banks like Goldman Sachs or Morgan Stanley eschew putting on very large events, preferring to organise intimate dinners for twenty-five or thirty investment clients. They like to entertain those who look after some of the biggest pools of money in the world, to sit down with, let's say, a member of the board of the ECB in a quiet setting, to quiz them about the details of their recently announced Outright Monetary Transactions, or to debate with

someone from the Financial Stability Board, the super-agency that co-ordinates bank regulation across countries, about the implementation of Basel III—an esoteric set of financial rules that will nonetheless be exceptionally important if banks are to survive the next crisis.

One does the rounds of these events for the people one might bump into. At a cocktail party at the Peninsula Hotel given by BNP, by some measures the world's largest bank, I chatted over gin and tonics with Agustín Carstens, Governor of the Central Bank of Mexico. Later in the lobby bar I encountered, Paul Tucker, Deputy Governor of the Bank of England. A few minutes later I spied Vikram Pandit, the CEO of Citibank, striding across the lobby, surrounded by a train of associates. For dinner that evening I headed over to the Palace Hotel, where as I waited in the lobby I caught a glimpse of Anshu Jain, the head of Deutsche Bank. And over this dinner I saw Jens Weidmann, the very youthful and hawkish Governor of the Bundesbank, having drinks with a group of his fellow country-men. Eventually I headed out to the Park Hyatt, the designer hotel occupying the top floors of the Shinjuku Park Tower, made famous by Sofia Coppola's film *Lost in Translation,* for late night drinks. Here I spied Pierre Moscovici, the French finance minister with his colleagues from the French Trésor. At another table sat Cristian Popa, the longstanding Deputy Governor of the National Bank of Romania—who, I am told, is a minor celebrity and something of a fixture at these global events.

But the real place to people watch was at the Imperial itself. For a few days the enormous lobby and its adjacent sunken lounge became the hub of global finance. Along the length of the lobby, which in the early evening was as crowded as a railway station, was a banquette; the perfect vantage point from which to watch the financial world go by. One afternoon I bumped into Lael Brainard, the Under Secretary of Treasury for International Affairs of the US Treasury, walking very fast and purposefully, with several aides in tow. In the evening Adair Lord Turner, the head of the UK's Financial Services Authority, who, just the night before, had given the Mansion House Speech in London, could be seen strolling through the Imperial's lobby. So too could Christian Noyer, Governor of the Banque de France. The renowned CNBC anchor Maria Bartiromo was chatting with the US Undersec-retary of State, while Raghuram Rajan of the University of Chicago, recently appointed chief economic adviser to the Indian government, was engrossed in conversation with a group of colleagues.

Few of these names are household figures, and at Davos they would not merit a second glance, but in the serious business of global finance, these are the rock stars. I am no longer part of that world, so who knows how many other countless figures of significance present in Tokyo walked past without my recognising.

As I watched the ever-shifting assembly wash through the Imperial, it occurred to me that important people always seem to stride briskly along, surrounded by aides or colleagues. I would find it exceptionally claustrophobic to be always so beset. But one afternoon, I did see Mario Draghi, President of the European Central Bank, a figure of true consequence in this world, emerge from an elevator by himself, stop for a moment to ponder, and then walk slowly across the atrium, deep in thought. I found it reassuring to see someone in such a position of power over the global economy immersed in contemplation.

A

All these public events, the seminars and panel discussions, press conferences and mock debates, serve essentially as entertainment. The real work goes on unseen in the offices and corridors of the Imperial. The rooms in the tower wing towards the rear are converted into temporary offices, suites of which have been assigned to each delegation. It is from here that the delegates do their business—which is to book themselves up with meetings from morning until midnight, as though taking part in a marathon speed-dating session for countries and bankers, though each date lasts more like half an hour rather than five minutes.

Walking through the corridors of the Imperial, I first bumped into an old colleague from my investment management days, now working for one of the largest European banks, who had come to pitch for an allocation of money from a large Asian sovereign wealth fund; and then into another old friend, a hedge-fund strategist based in London, who was visiting a contact in the US Treasury team. One sees squads of investment bankers, armed with PowerPoint presentations, come to propose privatisation deals; or analysts from the rating agencies who have to be courted and cajoled. As I got off the elevator I finally encountered the iconic sight of a harried finance minister—P. Chidambaram of India, no less—surrounded by a phalanx of aides: just what I had hoped to catch sight of at the Fund's offices in Washington.

Liaquat Ahamed

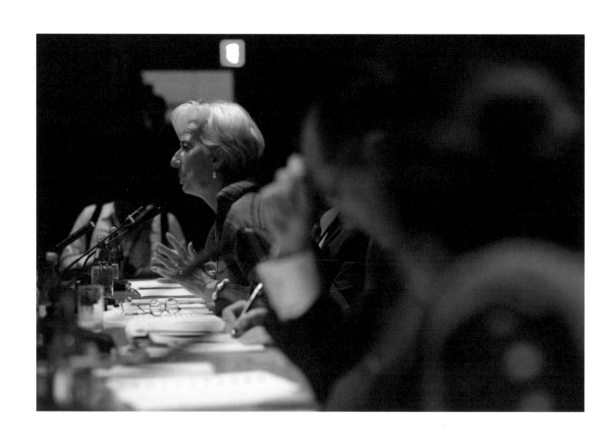

As at any other speed-dating event, some people are in higher demand than others. Every country borrowing money from the Fund, or expecting to do so in the not too distant future, seeks a meeting with the Fund management. Officials from the US Treasury and the German Ministry of Finance, who between them call the shots on so many national bailouts, are also in high demand. Of course the most highly courted person is the Managing Director herself, Christine Lagarde. Next in line come the Fund's Deputy Managing Directors, especially the First Deputy Managing Director, David Lipton, who previously worked in the White House and has a direct pipeline to the American economic policy team. A typical day for him would involve ten or twelve meetings. Some meetings are purely ceremonial and diplomatic, but some involve major decision-making. I wonder how he manages to retain all their various stories, and keep each of their complicated policy debates straight in his head. One evening he was summoned to an unscheduled and impromptu meeting about Greece, which lasted several hours and included other senior Fund management; the Germans, who are pulling all the strings in Europe; some board members of the European Central Bank; and US Treasury officials, all seeking common ground on what to do next.

S

Since so many of these meetings deal with highly confidential and sensitive issues, it is hard for an outsider to find out precisely what is going on. I did however manage to catch a glimpse of the cogs grinding while visiting a friend on the Pakistani delegation. The Pakistanis had been given a suite of six or seven rooms, located on the same floor and corridor as those of China, India, Nepal, Bangladesh, and Sri Lanka, which had been converted into rudimentary offices, each with a desk, a few chairs and a small table.

Dispensing with pleasantries, my friend launched into a weary lament about the state of his country. The Pakistani economy was (and remains) in bad shape, and was threatening to unravel. Hardly anyone paid taxes; the government had one of the worst tax collection records in the world. As a consequence, the gap between public revenues and expenditures stood at about seven percent of GDP, about half of which the government covered by printing money. Prices had been rising in double digits for years.

The economy was moribund, growing barely enough to keep up with population growth. Until now it had been kept afloat by remittances from workers in the Gulf and elsewhere. But recently, with the propertied classes frightened by escalating religious violence, capital had been fleeing the country and Pakistan was now losing foreign exchange reserves at a rate of $1 billion a month. If this continued, they could not last more than a few months before a huge economic crisis struck.

Normally in this kind of situation, a country would turn to the Fund. All Fund loans come with conditions, which go by the ugly name: "conditionality." The package of loans and conditions is referred to as an IMF programme. The rationale for the conditions is perfectly reasonable: the IMF needs some reassurance that its borrowers will take the necessary steps to get out of their temporary difficulties, so that they do not drown, but get back into a position to repay the Fund.

Back in the 1940s when the IMF was first set up, there was some disagreement about the conditions to be attached to its loans. The Americans, the main initial financiers of the enterprise, needed the most reassurance about being repaid and wanted very strict conditions. The British, who envisaged being one of the early borrowers, angled for leniency. Keynes warned against meddling too deeply in the internal policies of borrowers; this was too "grandmotherly" he said. To fully appreciate this comparison you must allow for the era and social milieu in which Keynes grew up: where in modern families, grandmothers tend to be highly indulgent, I suspect that in Keynes' time, they were rather telling their grandchildren how to behave. In the end, the Americans won the argument. And over the years, as the British have moved over to the creditor side of the equation, they have needless to say shifted their position.

The essential given behind most of the Fund's conditions is that countries get into financial trouble from too much borrowing. The source of these excessive debts can vary. Sometimes it is, as in Pakistan, the government resorting to too much deficit financing. At others it is banks that have over-leveraged themselves. Occasionally, it is influential companies running up large debts, and increasingly, as access to credit as become easier, it has been individual households that have collectively overextended themselves. Mostly, it is a combination of all these four. But when a country does find itself in financial straits, it is invariably because too much debt shows up somewhere in the system. Thus the conditions attached to IMF loans

almost always involve measures to cut borrowing, either on the part of the government by reducing public spending or raising taxes, or on the private sector by putting up the cost of credit, forcing banks to reduce lending and placing limits on foreign borrowing.

The central dilemma of course is that one cannot cut borrowing without someone cutting back spending. This means a hit to the standard of living. The sacrifice can take many different forms: higher taxes, lower wages, reduced benefits from government, higher unemployment. But there is no way to avoid the pain.

The Pakistani authorities knew that were they to approach the Fund for help, its officials would insist that, as a first step, the government cut the budget deficit from seven percent to three percent of GDP by raising tax collections and reducing spending on things like fuel subsidies which essentially benefit the better-off. There was bound to

You guys need to be tough with us. Otherwise nothing will change, we will just go back to the same old bad ways

be a political backlash. So with elections scheduled for the next year, the politicians were holding off seeking outside help.

The Pakistani delegation, recognising that they were likely to face a financial crisis the following year, had been preparing for the worst. They had met with a range of IMF officials to alert them to the situation, with Masood Ahmed, Director of the Middle East Department, and with Nemat "Minouche" Shafik, the Deputy Managing Director responsible for Pakistan. And just in case—since you cannot have too many friends in such a situation—they had also scheduled a meeting with David Lipton, who though he did not have direct responsibility for Pakistan at the Fund, knew of its problems intimately from his White House days as the international economics point man on the National Security Council. To make doubly sure that they had their ducks in a row, they met with Charles Collyns of the US Treasury and Undersecretary of State Bob Hormats. Furthermore,

Liaquat Ahamed

since you could never be sure that the Americans would come through, the Pakistanis had been canvassing for help from their neighbours as a back-up. That morning my friend had spent a couple of hours with the Saudis, who have been firm friends to Pakistan for many years, and could usually be relied upon to open up their chequebooks when the situation really got dire. Later in the afternoon he planned to see the delegation from the U.A.E. and a meeting was scheduled the following day with the Iranians to discuss oil supplies.

In addition to these meetings, my friend had been involved in the usual round of presentations to the rating agencies, Moody's and Standard & Poor's; held sessions with the Arab banks on which the Pakistanis rely extensively for trade credit; and had paid the requisite courtesy calls on Japanese companies with commercial ties to Pakistan.

My friend laughed cynically when I described the round of parties he had been missing while stuck indoors all day and into the evening, shuffling through the corridors of the Imperial from one office to another. After dinner he would stagger back to his hotel and return to the same frenetic round of passing round the begging bowl early the following day.

The Pakistani officials, grimly aware that their government could not continue to print money indefinitely, broadly agreed with the direction and types of measures on which the Fund would insist, though they might quibble with the pace of the cuts that it would demand. But my friend feared that the politicians, complacent about what had to be done, would drag their heels. For the last decade they had relied on Pakistan's strategic importance to the US in the war on terror and seemed to be planning to play that card indefinitely.

Within the corridors of the IMF, the Pakistanis are notorious for never keeping their commitments. Since the late 1980s they had borrowed eight different times, and on seven of those occasions failed to meet their targets. His political masters, sighed my friend, were once again counting on being bailed out without having to do very much. Ironically, his biggest fear was that they would prove to be right, that Pakistan was too important strategically to the US and that the US government would pull out all the stops to prevent an economic meltdown, including pressuring the Fund to go leniently.

"You guys need to be tough with us. Otherwise nothing will change, we will just go back to the same old bad ways," he said. I told him that attitudes towards Pakistan in Washington had changed, that it would no longer get a free pass by brandishing that war on terror card.

W

When the representatives of 188 sovereign nations gather in some grand forum, the proceedings generally degenerate into theatre, with much posturing, long boring speeches designed to impress rather than to persuade. That does not happen at the IMF meetings. The main spectacle—the plenary session—is brief. In Tokyo this lasted only a couple of hours, and there were in total only four speeches: by the Crown Prince of Japan, as host; the Managing Director of the IMF Christine Lagarde; Jim Yong Kim, President of the World Bank; and the Chairman of the Board of Governors, Riad Toufic Salameh, head of the Central Bank of Lebanon. Some forty other Governors did have statements to make but, mercifully, these were not spoken but inserted into the record of the proceedings after the fact.

All of the real activity at the meetings takes place off centre stage, behind closed doors. Aside from all the speed dating earlier described, referred to in the jargon as "bilaterals", the various nations or groups of nations take the opportunity of being in the same city for a few days to hold a series of caucuses. One afternoon the finance ministers of the Association of Southeast Asian Nations, who see one another frequently anyway, snatch an hour together. Another morning the African Central Bank's governors have breakfast together at the Imperial, while over at the Okura the Caribbean finance ministers hold an extended three-hour session.

Most of these sidebar meetings, driven by the simple imperatives of geography, generate little, or no, attention. The Commonwealth, which has its own energetic secretariat in London, run by a Secretary General (currently a retired Indian diplomat), organised a day and half of meetings. Sadly the only thing that seems to unite its fifty-four nations—which range from well-developed raw-material producers like Canada and Australia, to the kleptocracies of West and Central Africa, from the emerging economies of India to a plethora of tiny Caribbean island states—is the historical accident of having been colonised by the British. Rather less than forty finance ministers bothered to turn up. Conspicuously absent were the British, who, despite being the mother hen of this shapeless organisation, had decided that, with Britain approaching a second recession and debt problems of its own, their officials had more important things to do than to spend several hours listening to the problems of minute, over-indebted

70

Caribbean islands. Journalists seemed similarly uninterested. At the press conference that followed, chaired by the Prime Minister of St Kitts and Nevis, barely a dozen journalists turned up.

It is the backstage machinations of all the various Gs, the groups of countries like the G-7, the G-20 and the G-24; which seems to provoke the most interest and gossip—perhaps because these code names signal who runs the world. Until recently it was the G-7, a club of rich countries which began in 1975 as the G-5—the US, Japan, Germany, France, the UK, and later Italy and Canada. For the last thirty years or so, the G-7 finance ministers and central bank governors would meet every six months to assess the state of the global economy and discuss what might be done individually and collectively to keep it on track. The group saw itself as the economic steering committee of the

The meeting was beginning to feel like a high-school reunion where long-dormant grudges that had been simmering below the surface boiled over

world—a position no one thought to question because its members were so much wealthier and more powerful. At every IMF annual meeting, the G-7 would hold a much-publicised but private confab.

In the fall of 2008, when the richest countries were hit particularly badly by the financial crisis, the G-7, recognising that it needed the help of other countries to stem global collapse, handed over its role as the committee in charge of running the world to a wider group, the G-20. This consisted of the G-7, twelve other countries that were either rich or large (Australia, Saudi Arabia, India, Russia, Turkey, South Africa, Argentina, Brazil, Mexico, China, Indonesia, South Korea), plus a representative of the European Union.

To get some idea of how this curious amalgam manages to work, I headed over to the Imperial Hotel one morning to meet a friend from the Indian delegation. He was not happy. Before long he began

Liaquat Ahamed

venting about the G-7. Apparently the previous afternoon, the G-7 finance ministers had met in private. Knowing that such a reunion of a group that had supposedly handed over power to the G-20 would raise eyebrows, the so-called "sherpas" who organise these things did not advertise the meeting; indeed they very explicitly kept it off the official schedules. But with everyone scurrying around the Imperial between the same limited number of conference rooms, it was hard to keep such a reunion under wraps. As word of the meeting filtered out, the Indians, who tend to be unusually touchy about such matters, as well as other of the delegates of the G-20 countries, became quite irritated—a simple reflection, I suppose, of the fact that people deeply resent groups from which they are excluded. Particularly when power or status is involved, as anyone who remembers their high school days can relate.

The story of the G-20 itself illustrates the pitfalls and sensitivities involved in any attempt to establish a hierarchy among countries. It had begun life in 1997 as the G-22, when the G-7 organised a gathering of the finance ministers and central bank chiefs of twenty-two countries—the G-7 countries and fifteen others—to look into plans to reform the international finance system after the Asian Crisis. In early 1999 a further eleven countries were added to create the short-lived G-33; but it soon became apparent that this was too cumbersome a group, so within a few months the decision was taken to pare the number of members down. Another simple lesson from high school is that nothing creates greater offence and resentment than being dropped from a clique, however tenuous its status. Indeed some of those who were excluded, for example, the Netherlands and Spain, refused to take no for an answer and, though strictly speaking not members of the G-20, are often to be found at the table.

The most vocal critics of the ongoing informal existence of the G-7 are the BRICS countries. The BRIC group was born in 2001 out of Brazil, Russia, India and China, identified by Goldman Sachs as the four emerging market countries whose size and economic growth would, according to the investment bank's seers, lead them to dominate the global economy. Somewhere down the line South Africa was added to this forecast, probably because someone felt that political correctness required that Africa be represented.

As some of the BRICS countries have come to see themselves as the G-7 of the mid-21st century, they themselves have become the object of envy, especially by the other members of the G-24—a group

of developing countries, including two BRICS, Brazil and India, but also countries as diverse as Algeria, Côte d'Ivoire, Ethiopia, Peru, and Syria, with China as a sort of associate member, in its overwhelming extra-category way. Further to confuse matters, it should be said that the G-24 does not speak only for itself but acts as the voice on international financial affairs for an even larger group, the G-77 developing countries, which in turn was created in 1964 by seventy-seven developing countries, but actually now has 131 members, retaining its original name for baffling reasons.

After this lunch my Indian friend was called off to a meeting of BRICS finance ministers and their aides, after which was scheduled a summit of the G-24 finance ministers. The most common criticism of the BRICS is that it is an artificial creation, dreamt up by a bunch of investment bankers in London with few if any common economic interests to tie it together. Over the last four years the BRICS have held annual summit meetings, trying to find ways to act in concert, with little success.

The one topic on which there seemed to be a community of interest, and which was now top of the agenda at the meeting he was to go to was, "quota reform." For the last few years the emerging market countries, but again especially the BRICS, have been pushing for a greater say within the Fund. Since a country's vote within the organisation depends on its quota (the amount it is required to contribute to the Fund), they have been agitating to change the way quotas are set.

At the moment, the quota is calculated from a seemingly scientific formula that captures the size of the economy, its openness to trade and capital flows, and its vulnerability to fluctuations. Its essentials were developed back in the 1950s. The arguments for including the size of the economy are self-evident. The rationale for the other factors in the formula, for example openness, is that the more trade a country does, or the more it depends on international capital flows, the greater the likelihood that it will face financial difficulties and thus require outside financial help. As my friend, a numbers jock and something of an expert in this area, described all this, it all sounded quite plausible, though calibrating the weights of each variable, I remarked, must be a highly subjective exercise.

The emerging market countries, led by Brazil and India, were now pressing to have the formula completely revamped, reducing, and even perhaps eliminating, the weight attached to the component measuring openness. This might all sound esoteric and somewhat geeky, but it

turned out that behind the debate lay a bare-knuckled fight about influence at the IMF. Countries within Europe do an enormous amount of trade with each other. Under the current formula, this boosts their quota at the expense of the large continental size economies that make up the BRICS. It leads to some obvious absurdities. Little Belgium with a population of little more than 11 million has a higher quota than Brazil, which has a population of almost 200 million and an economy more than five times as large as Belgium's. And if you put Holland and Belgium together, they have a larger quota than China's. Although the Europeans pay lip service to the notion that power within the Fund has to shift in line with changes in relative weights within the global economy, they had been dragging their feet, my friend recounted.

He continued to reel off a litany of complaints about excessive European clout within the Fund—their apparent lock on the Managing Directorship, the disproportionate amount of Fund money that has been directed to saving the Euro, the double standards with which Europeans have been treated in these bailout packages compared to comparable programs during the Asian Crisis or in Latin America.

Hearing all of this, it occurred to me that putting all these people together, far from promoting international goodwill, might exercise the opposite effect. The meeting was beginning to feel like a high-school reunion where long-dormant grudges that had been simmering below the surface boiled over. When I met my friend eighteen months later, he was even more incensed. Not only had there been no movement on a shift in the way quotas were to be recalculated, the negotiations had actually gone backwards. The U.S. Congress, fearing that any changes in quotas would dilute American influence within the Fund, had refused to pass legislation authorising the contribution that the U.S. was supposed to have made back in 2010. Any further discussions on quotas were consequently at a stalemate.

Though none of the paranoid conspiracy theorists, who have long been fascinated by the Fund, were obviously in evidence in Tokyo, if they had been there I suspect they would have dismissed all this messy politicking within the G-20 or between the G-7 and the BRICS as surface distraction with little significance. In looking for the signs of who is in charge of the global economy they would have trained their sights on the mysterious G-30. This is not just one more configuration of countries but something potentially of much

more power and personality: a group of thirty of the most puissant people in finance—current and former central bankers, the heads of the world's biggest banks, ministers of finance and a handful of prominent academic economists. Part of the mystique of the group comes from its name, at once understated and grandiose, as if to suggest that this fraternity of thirty wise men might carry the same weight in world affairs as the G-20 group of countries. They gather twice a year in the plenary session at the headquarters of one of the major central banks—the last three sessions have been at the Bank of England, the Swiss National Bank and the Federal Reserve in New York. Though they organise study groups on such high-minded topics as "Investment Time Horizons" or "Governance of Financial Institutions", which result in glossy reports, it is hard to believe, with so much talent and raw power around the table, this is all they are up to. At the annual IMF meetings they host an invite-only discussion day. To a conspiracy theorist, this could all sound sinister. Were the conspiracist to study the list of members, though, he would be immediately disarmed. For there he would find Paul Krugman, Nobel Laureate in economics, *New York Times* columnist and general gadfly. It is hard to imagine any group including such a figure up to underhand oligarchic mischief.

|

It is often the case at these gatherings that a single topic comes to dominate the general discussion, crowding out all other issues. Social psychologists surely have a good explanation for this; it's as if the collective psyche is incapable of holding more than one big thought at a time. In Tokyo, there was much competition for space.

As a result of the dispute between China and Japan over eight uninhabited islets in the East China Sea, the most senior Chinese financial officials, the Minister of Finance and the Governor of the People's Bank of China boycotted the meeting, sending deputies in their stead. The major fear was that a conflict between the two largest trading nations in Asia could escalate and damage an already fragile global economy.

Second in line was the possibility of a cataclysm in Europe if Greece were to default. Third came the failure to move on quota reform and the increasing stalemate on shifting power within the Fund from the

Europeans to the BRICS. In this event, it was the unlikely subject of fiscal multipliers that came to dominate the corridors of the Imperial.

It started with the usual presentation at the beginning of the week of the IMF's World Economic Outlook, the flagship report that presents its assessment of the global economy. Some 250 journalists crowded into the seventh-floor briefing room at the International Forum to hear the Fund's forecasts. Official organisations always face a dilemma when they pronounce on the economy during bad times. Too frank an assessment of the situation may add to the general pessimism and make things worse. Recognising that what they have to say can affect what actually happens—like Heisenberg's uncertainty principle—they invariably err on the side of caution. Despite the slightly anodyne flavour that this imparts to the Fund's forecasts,

You have to imagine the IMF as the doctor. The money is the medicine. But the countries—the patients—have to change their habit if they want to recover. It doesn't work any other way.

the presentation of the WEO attracts a standing-room-only crowd year upon year—as it did in Tokyo.

The presentation was led by Olivier Blanchard, the Chief Economist and Economic Counsellor of the IMF, a title invented to convey that he is more than a box on an organisation chart, but has the ear of the Managing Director. Blanchard is tall, with the craggy squint-eyed looks of a Western movie star. In other words he does not look like your average practitioner of the dismal science. He is, however, one of the most innovative thinkers in macroeconomics, the eleventh most cited economist in the world (six of the ten ahead of him in those league tables carry Nobel prizes), and taught at MIT before taking his present job in September 2008. Blanchard, as his name reveals,

is French, something only unusual because France has a tradition of producing political rather than analytical economists. After completing his BA at Paris Dauphine University, he came to the United States for graduate school, and was awarded his doctorate from MIT in 1977. Blanchard is part of this school's gifted generation of economists, a crop that includes Paul Krugman, Fed Chairman Ben Bernanke, ECB President Mario Draghi and Ken Rogoff.

Since he came to the Fund just a couple of weeks before the Lehman collapse, Blanchard's tenure has been dominated by the slump that followed. Under his direction, Fund researchers proceeded to dissect what history had to teach us about the aftermath of such crises. What could we expect in their wake? What, if anything, could be done to mitigate their consequences? What sorts of policies have promoted recovery?

In April 2009, at about the very lowest point in the cycle, the Fund published research indicating that, were history anything to go by, the global recession that followed the 2008 panic would be long and severe, the recovery sluggish. Unusually high levels of public debt would mute the effectiveness of stimulus measures. Six months later came a report stating that most countries take many years to fully get over financial crises. The collapse would leave permanent scars in the world's economic tissue. This was followed up by a piece in April 2010 that suggested that not only did financial crises hurt output, they also had seriously ill effects on unemployment. This body of work sounds unremittingly bleak, but it served well to prepare policy makers for the long haul that faced them (and largely still does).

As more and more of the world began to worry about the consequences of the debt overhang—both the high levels of household indebtedness built up during the boom years, and the gigantic debts that governments had accumulated over four years of running big deficits and bailing out banks—the group responsible for the WEO began to shift their focus. In the October 2010 issue, they published a chapter entitled, "Will it Hurt? Macroeconomic Effects of Fiscal Consolidation", which demolished the view, prevalent in Europe at the time, that fiscal austerity could be painless. Blanchard sees part of his role as that of an "intellectual irritant," whose job it is to question conventional wisdom, including that within the Fund. The work had his mark all over it.

At the press conference given by Blanchard and his key lieutenants, most of the journalists zeroed in on Box 1.1, page 41, of the report

entitled, "Are We Underestimating Short-Term Fiscal Multipliers?", authored by Blanchard and a young associate Daniel Leigh. The starting point of their analysis was the observation that, over the past couple years, the Fund had severely underestimated the severity of the economic contraction in a large number of counties. Were there systematic reasons for getting things so wrong? They found that the Fund had made its worst misjudgments in those economies where fiscal austerity had been the greatest. The inescapable conclusion was that shrinking the budget had done much more damage to the economy than previously assumed. According to their calculations the Fund had miscalculated by a factor of three.

The press latched onto the Fund's admission of error, calling it an amazing mea culpa. I, however, took comfort in the notion that the organisation had the internal dexterity to recognise, understand and draw lessons from its errors. It seemed to me as close to evidence-based medicine as one could find in the field of economic policy making.

In any case, had it not been for Mme. Lagarde's press conference that next day, the issue of fiscal multipliers would have been surely too abstruse to excite more than a devoted minority. When asked what the new research implied about the future pace of budget cuts in Europe, she replied that perhaps they should be slower and less front-loaded. That afternoon the German Finance Minister Wolfgang Schäeuble gave an interview in which he voiced strong disagreement. Suddenly all anyone wanted to talk about was the brewing conflict between Germany and the Fund. Every conversation I had for the next two days, whether at the Starbucks next door to the Imperial, over a Japanese dinner at the Okura, or coffee at the Italian café behind the Peninsula, ended up speculating about the rift. One afternoon a rumour circulated that Dr. Schäeuble had stormed out of a meeting in a huff.

This last was completely implausible. Later that day Dr. Schäeuble and Mme. Lagarde appeared on stage together at a televised debate organised by the BBC. The host tried his best to get them to disagree on camera but they both were far too politically shrewd to fall for his tricks, insisting that they were the best of friends and agreed on almost everything, despite Dr. Schäeuble saying that we must press on with austerity and Mme. Lagarde's suggestions that one had to be flexible, and that a mid-course correction might be appropriate.

Because much of what counts at the Fund meetings takes place out of sight and behind closed doors, rumours circulate freely and easily. While they certainly added a certain sense of drama to the remainder

of the week, they also lent a false air of alarm.

With the spotlight now on the Germans, I made special effort to seek out the events at which they were speaking. One afternoon I attended a panel discussion organised by Deutsche Bank, which included Olli Rehn of the European Commission, who is Finnish and one of the key architects of the current austerity strategy within Europe; Jörg Asmussen, the German member of the ECB Executive Board, and by his country's standards a dove on austerity; and Klaus Regling, the German CEO of the European Financial Stability Facility, which provides the bailout money to European countries in distress.

Though they never quite came out and said it, Fund officials speaking on European issues in Tokyo often gave the impression that there may be no satisfactory solution: that ultimately countries in crisis within Europe face the choice between one set of policies that are unpalatable and another that are unacceptable. By contrast the Germans appear to be totally without doubt. So convinced did they seem of their rectitude, that they come across as rigid and dogmatic—dare I say it, Germanic.

In an effort to make themselves better understood, economic officials frequently resort to analogies. At times, rather than being illuminating, these can be confusing. When someone asked the panel why, in view of the costs exacted by fiscal austerity on the social fabric of the countries in crisis, it did not make sense to go slow on budget cuts, Asmussen tried the following comparison: if you plan to cut off a cat's tail, better to do it in one fell swoop, rather than in slices. This left the half-Japanese audience quite bewildered: why would anyone want to cut off the tail of a cat in the first place?

|

In trying to explain what they do to the wider public, IMF officials have long resorted to medical analogies. The script runs some-thing like this: countries in financial trouble are like sick patients. Going to the Fund for help is like visiting a physician, or more appropriately the emergency room.

The former Managing Director, Dominique Strauss-Kahn, in an interview in 2010 with *Der Spiegel*, put it this way: "You have to imagine the IMF as the doctor. The money is the medicine. But the

countries—the patients—have to change their habit if they want to recover. It doesn't work any other way." The IMF's prescriptions, like many medical remedies, may not make you feel immediately better, but they are necessary and beneficial in the long run and no cure is possible without some painful behavioural changes. In other words, the IMF's money may help but what is really required is some tough love.

There is a further reason why I find these medical comparisons particularly illuminating. The practice of economics in its current state is in many respects comparable to the practice of medicine. The grasp of even the most expert economists of the way the economy functions is probably less than our still-imperfect knowledge of human anatomy. There are many things that the profession does not does not understand and can't predict or foresee, particularly about the behaviour of an economy in periods of trauma and stress.

For example economists are uncertain about the pace for cutting borrowing. They do know that going cold turkey on more debt destroys jobs and can wreak enormous harm on the economy in the short run. Indeed, the very creation of an IMF to provide lending to countries in difficulty was based on the recognition that it may be the right thing for them to keep borrowing temporarily. On the other hand, they recognise that eventually a country has to learn to live within its means. So like doctors unsure about the size and dose of prescriptions of experimental drugs, they have to improvise.

Doctors also know that patients vary in their response to treatment depending on their individual genetic makeup and overall health. So it is with countries. Their ability to deal with economic pain varies according to their history and social structure. Trying to predict how a country will cope with the typical IMF program involves guessing such things as how far taxes can be raised or welfare benefits cut without triggering destabilising mass protest, or how far wages can be lowered without provoking labour unrest. With so many imponderables, it is not surprising that developing an economic program for a troubled country is less a matter of number crunching and more a question of judgment.

Moreover, with the best will in the world, even the most rigorously trained, experienced doctors will misdiagnose on occasion. The Fund equally has its casualties. It is now generally accepted, for example, that its handling of the Asian crisis of the late 1990s was badly judged, and that it therefore prescribed the wrong solutions. Until then the

most common problems that it had encountered—for example in Latin American in the 1980s—had been governments running excessively large deficits. The cure was fiscal austerity. The Asian crisis of the late 1990s arose from a completely different problem—massive inflows of capital from abroad fuelled by excess borrowing by local banks. So although Asian governments had managed their finances prudently, the Fund tried to apply the same prescription of fiscal austerity. An economic disaster was only avoided by reversing policy at the last moment.

Like any analogy, the medical comparison can only be taken so far. The body politic does not consist of just one entity. When I am at the doctor and I am warned that this will hurt, I don't wonder which of me will feel the pain. By contrast when politicians are asked to inflict economic pain on their country, their biggest worry is how that pain is to be shared and whom it is going to hurt the most. It was with these thoughts in mind that I headed off to join a Fund mission to Ireland.

85

Dublin

PLEASE KEEP OFF
THE LAWNS
ná gabh ar na
faichí, led'thoil

Elliott & FitzGerald

FOR SALE/
TO LET

OFFICE BUILDING
+ MEWS

661 4403

www.elfitz.ie

myhome.ie

I arrived in Dublin on a cold and foggy morning in October 2012. Over the previous four years the economy had collapsed, having contracted by more than ten percent—a dramatic fall by modern standards. The typical Irish family had seen its standard of living fall by almost a quarter; one in seven of the labour force was unemployed.

In November 2010 Ireland had been to close national bankruptcy and had to be bailed out with a loan of €67.5 billion. The money had been provided by the other countries of European Union and the IMF, which put in €22.5 billion, making Ireland the Fund's third largest borrower. In addition the European Central Bank had at the time been separately owed over €100 billion by Irish banks in trouble. The total amount that Ireland had had to borrow to see it through its troubles was the equivalent of an astounding $50,000 for every man, woman and child in Ireland.

Since early 2011, a joint mission from the IMF, the European Commission and the European Central Bank had visited Ireland every three months to assess how the economy was faring under this emergency care, and to monitor progress in meeting the conditions on the loans, most of which had to do with fixing the collapsed banking system and drastically cutting the budget deficit. If I wanted to see up close what it was like to be bailed out by the IMF, here was the perfect case study.

W

When quizzed by the man at passport control about the purpose of my visit, I told him that I was writing about the IMF. His interest was immediately piqued. He obviously knew the Fund was coming to town; indeed when I later scanned the newsstands I discovered that most of the Irish papers had run pieces heralding the mission's arrival.

Liaquat Ahamed

Almost everyone I spoke to that day—the cab driver, the waiter at the café where I lunched, a man at the bookstore—seemed acutely aware that the Fund had landed.

"So how many of you are there?" he asked, thinking that I was part of the mission.

"About eight or nine," I replied.

"That's not very many."

I did explain that the IMF had not come alone, but was working in league with the European Commission and the European Central Bank, each of which sent a similar-sized team. He seemed reassured. Perhaps he had been unnerved at the thought of a mere

At the bookstore on Grafton Street, next to a table piled with books about the Irish Famine of 1848, beside the section devoted to Ireland's civil war, is a whole shelf devoted to the country's current miseries.

eight young economists from Washington DC holding his country's future in their hands.

The man's whole demeanour took me by surprise—there was a rueful shake of the head, a resigned sigh, but not the slightest hint of hostility. His body language seemed to say, we understand it's not your fault, you're just doing your job. We brought this on ourselves.

There was no hint of the negative reaction that I had expected. In large parts of the world, the Fund has become a byword for unfeeling austerity, conjuring up images of hard-faced men with red pencils. Especially in countries to which the Fund has lent, it provokes the sort of vehemence once reserved for the CIA.

Much of this is fully understandable. For the general public, it

must be traumatic to see foreign bureaucrats take charge of the country's finances, and to have to watch the government's highest officials answer to them. Ask anyone over the age of fifty in Britain, and they can vividly remember the collective sense of humiliation in 1976 in the lead up to the "Winter of Discontent", when a country that had once run the world seemed unable to manage its own affairs, and was compelled to go hat in hand to the IMF. And yet here in Dublin, based on the reaction of this one immigration official, it seemed as if the Irish were almost in the mood to welcome foreign intervention. It was going to be an illuminating visit.

On the drive in from the airport I could see the familiar shipwrecks of a real estate boom gone wrong: vacant office blocks for rent, deserted housing estates, half-completed corporate headquarters. These are familiar sights. You can find similar ruins on the outskirts of Madrid, in the tracts around Las Vegas or in the suburbs of Phoenix, Arizona. This is what real estate bubbles and smashes look like. If you travel around China, you may see the early stages of these: abandoned complexes, unfinished high-rises, and vast newly built cities without residents.

As we crossed the River Liffey, the looming skeleton of the now abandoned headquarters of Anglo Irish came into view. Run by the maverick Sean Fitzpatrick, the bank was the largest to have gone under here. It had no deposit base to speak of, but over a decade had managed to increase its loans to a handful of property developers from €3 billion to €75 billion. To put that in perspective, the bank had gone from nothing, to having an absurdly large balance sheet equivalent to half the GDP of all of Ireland. The American equivalent would be a bank's ascent from nothing to $7 trillion, three times the size of J.P. Morgan. Each city produces its own distinctive monuments to the folly of property speculation. This is Dublin's.

At the bookstore on Grafton Street, next to a table piled with books about the Irish Famine of 1848, beside the section devoted to Ireland's civil war, is a whole shelf devoted to the country's current miseries. I was quite surprised at the number of books that had already been published with knowing, embittered titles such as: *How Ireland Really Went Bust*; *Ship of Fools: How Stupidity and Corruption Sank the Irish Tiger*; and *The Bankers: How the Banks Brought Ireland to its Knees*. These titles suggest the books' basic theme: this was all the fault of a small coterie of greedy and dishonest bankers and their developer cronies, helped along the way by a generation of venal politicians who had not a clue what they were doing.

Liaquat Ahamed

To find out more, I decided to follow an age-old technique for gathering economic intelligence, passed on to me by an old IMF hand. I hopped into a taxi and struck up a conversation with my driver. It turned out that he had strong opinions. A small middle-aged man with a messy tufts of hair and a little goatee, he punctuated every sentence with the phrase, "Know whatta mean?"

The cab driver had a long roster of culprits for Ireland's troubles: "the clowns we put in charge, who made such a mess we now have guys like you come sort us out"; the Germans; Sean Fitzpatrick; Irish women. All his friends apparently had been goaded by their wives to buy big houses and take out mortgages beyond their means, which they were now regretting, as it would take the rest of their lives to pay these off. He, on the other hand had avoided getting in over his head; he lived in a modest house with a small mortgage because he liked to work as and when he wanted. He told me he was divorced.

As we drove through the elegant squares and avenues of South Dublin, passing terraces of empty Georgian townhouses plastered with *To Let* or *For Sale* signs, he launched into a long and complicated analysis of the Irish national character and its capacity for self-delusion—my words not his. Dropping me off at my hotel, he recommended I take a walk through the gardens of Merrion Square. Later that afternoon as I strolled through the park, I encountered a memorial to Oscar Wilde, who was born at No. 1: a sculpture of the dandy reclining on a rock with a knowing smile on his face, dressed in a colourful coat. Next to it were two pillars carved with some of his most wonderfully cynical aphorisms. One in particular was telling: "The only thing I cannot resist is temptation."

|

It turned out that many people on the street were ready for long conversations about the economy. Ireland is a tiny place, as people never cease to remind you, and everyone has been affected by the crash. After a diatribe against the usual suspects (the bankers, the politicians, the Germans), at some point talk will turn to the luck—or more accurately the rotten luck—of the Irish. While people have finally let go of the notion that they were destined to be the poorest country in Europe, with a unique capacity, indeed talent, for suffering, the national psyche is still dominated by some variation on what

American politician Daniel Patrick Moynihan once said: "To be Irish is to know that in the end the world will break your heart." In fact what Ireland has been forced to deal with is in no sense unique, though what may be unusual is the depth of the hole it has dug for itself.

To understand what happened one must go back a generation. Ireland in 1980 was one of the poorer nations of Western Europe. Its main natural resource, and its biggest export for close to 150 years, had been its people. Suddenly in the mid-1980s the country set out to remake itself. Instead of passively allowing its most talented people to leave for Britain or America or Australia, it concentrated all its efforts on keeping them at home, while encouraging foreign companies to move the other way. The government slashed public spending and slimmed down a welfare state it could not afford, cut wages and reduced taxes to attract overseas investors. Within a few years, high-tech companies like Microsoft and Intel and big pharmaceutical manufacturers such as Merck and Pfizer had not only set up shop in Ireland but established their European hubs there. During the 1990s, the island, now dubbed the "Celtic Tiger", grew at almost ten percent per annum, making its economy one of the most dynamic in the world.

With their incomes rising so fast, the Irish collectively, and quite naturally, decided it was time to move to nicer homes. As everyone tried to scramble up the ladder, house prices began to soar. Few things are more seductive than becoming apparently richer with no effort, by simply purchasing a home with borrowed money. Half the population got into the act of buying and selling houses. Mostly, though, they bought. Why sell anything if your place was going up at twenty to twenty-five percent a year?

If you could become moderately rich owning one or two houses, why not own three or seven or ten? People started accumulating whole blocks-worth of houses to rent. I recently stumbled upon the case of a seventy-one-year-old pensioner in an Irish newspaper, who over a twenty year period bought a total of twenty-one houses and apartments, altogether only letting go of three along the way. At the peak of the market he and his wife had a portfolio of seventeen different investment properties, not counting their own home, on which they had a €2 million mortgage.

As is now a familiar story, prices began to lose touch with reality. By 2007, a two bedroom flat in the centre of Dublin that five years before had cost €150,000 was going for €500,000. A stockbroking firm

issued a report saying that because of the distinctive demographics of Ireland—the sudden and unusual influx of immigrants into a country used to losing people, and a baby boom that had come later than to the rest of the developed world—the country was faced with a drastic housing shortage; that, far from being overvalued, houses were still underpriced.

We know that Ireland was not unique. The real estate bubble was a global phenomenon, fuelled by banks from every corner of the world, all seemingly awash with cash. Only the staid old Germans—and of course the Swiss—kept out of the collective madness. But by many measures Ireland's was the biggest of the bubbles. Dublin real estate went up fourfold in a decade, whereas in London it went up threefold

If you could become moderately rich owning one or two houses, why not own three or seven or ten? People started accumulating whole blocks-worth of houses to rent.

and in Florida, the most speculative of the US markets, only two and a half times.

What gave the Irish bubble its distinctive shimmer, and what has made the burst so extreme, was the response of the Irish banks. Ireland is a tiny place, with a population of only four million. The whole Irish economy, however fast it was growing, amounted to less than €200 billion at its peak—about the size of Connecticut's. So when its real estate boom took off and its banks decided to get in on the act, they found they only had €100 billion in deposits from locals to play with.

And so they embarked on their own borrowing binge, acquiring funds from wherever they could—deposits from foreign banks in Ireland, deposits from banks in London, Luxembourg and every financial centre, issuing bonds of various stripes and maturity to foreign investors. Altogether the bankers raised €175 billion in this

Liaquat Ahamed

way. In total the banks pumped close to €300 billion into real estate loans, a third into residential mortgages, but two-thirds—and here was the real killer—in loans to a handful of property developers.

Who was to blame for all this? It is hard to tell. Something of a chicken and egg problem seems to recur in every bubble. The Irish love to blame the property magnates and their bankers. But would the developers have borrowed such vast amounts, would the bankers have embarked on such a reckless lending spree, had the general public not collectively taken leave of its wits? On the other hand would the public have acted in this way had it not been dangled carrots of gold? The bankers were supposed to be the smart guys. Had they themselves not left their senses behind, disregarding all past conventions on how much to lend and to whom, the bubble may have collapsed much earlier for lack of oxygen.

<p style="text-align:center; font-size:2em;">T</p>

The Irish public seemed to reserve their greatest bitterness, however, for the way politicians and officials handled the crisis once it hit. By 2007, the Irish economy, although superficially booming, was in deep trouble. But no one except for a couple of outsider economists seemed to recognise this. Growth had become increasingly lopsided as construction absorbed close to 300,000 workers—one eighth of the work force. Tens of thousands of people, some of whom may have otherwise found route into another profession, found they could leave school and earn a good living on building sites. The country now boasted the highest percentage of household debt to income in the world. Irish banks had made loans of €450 billion, three-quarters of this property-related; the equivalent of half a million dollars for every family in Ireland.

What made the situation especially vulnerable was that half this funding for the banks came from abroad, money that was inherently skittish, that would flee at the slightest hint of trouble. That happened in early 2007. As real estate began to peak in the US, Irish property prices stopped climbing. It is in the nature of property bubbles that prices cannot remain still. The Irish had been buying houses because prices had been going up. When the rise halted, the motive to buy disappeared. Flat prices therefore became a reason to start selling. Prices began falling. Having soared much higher in Ireland than

elsewhere, they went down correspondingly harder. Construction ground to a halt and the economy started to slide. The banks were blindsided by a wave of defaults—real-estate developers unable to sell their inventory, construction companies whose business had evaporated, laid-off homeowners unable to meet their mortgage payments.

Just as Ireland was struggling with its own real estate crash, the US financial crisis hit. The collapse of Lehman Brothers caused the world's financial system to seize up. In the fateful week after Lehman, foreigners pulled a massive €60 billion out of Irish banks. The government panicked, terrified that all €200 billion that its banks had raised abroad could evaporate in a matter of weeks. On September 29th it issued a blanket guarantee of the deposits and debts of the six major Irish banks, an obligation that amounted to €400 billion, roughly two and a half times the country's GDP.

If Ireland had only been dealing with investor panic, brought on by disruptive financial markets but essentially psychological in origin, the guarantee could have been viewed as a bold but necessary move. But since Irish banks were up to their necks in potentially bad loans, it proved to be an astonishingly foolhardy gamble. In the short term it actually did stabilise the situation by drawing money from abroad, but within a few months reality was to reassert itself.

The economy was hit by a triple blow. The combination of the slump in construction, the fall in personal spending caused by the decline in house prices, and the distress of the banks drove the economy into a steep nosedive. The GNP, the best measure of standards of living in Ireland because it excludes the profits of foreign-owned firms, fell by over fifteen percent.

The economic depression—for that seems to be the best word for it—knocked a huge hole in the budget. At the peak of the boom, one-third of all government revenues came from real estate taxes of various types. With all that revenue now gone, and unemployment benefits and other social welfare payments soaring, the annual gap between revenues and spending shot up to €20 billion, close to fifteen percent of GDP. Before the crisis, Ireland's public debt position had been among the best in Europe: overnight it became one of the worst. The combination of enormous budget deficits with the ever-rising cost of the bank bailouts put the credit worthiness of the whole country into jeopardy.

Irish officials displayed much greater competence in dealing with budgetary problems and shoring up public finances than they had

handling the banks. In 2009 and 2010, €10 billion were shaved from the deficit, about a third by raising taxes and two-thirds by cutting expenses. The government cut public sector pay by five to ten percent, scaled back employment rolls, trimmed social welfare payments—previously generous by international standards—and rolled back tax exemptions. Even though the Irish authorities recognised that budgetary austerity would, in the short term, make the economic situation much worse, they saw little choice. The chasm between taxes and spending was so large that to do nothing would have put into jeopardy the confidence of foreign investors and hence the viability of Irish banks. Moreover, despite the grim economy, the wider public actually seemed to wel-

Because the guarantee had allowed large groups of bank creditors to walk away scot-free, the full burden of the bailout fell on taxpayers. Once the bills were in, the total cost came to €64 billion, or some forty percent of GDP.

come the move to fiscal austerity. The government was seen to have become excessively bloated during the boom years.

By early 2010 it was apparent that the banking system's total losses were going to be enormous—almost twenty percent of its loans, or €90 billion. The Government was forced to close down two banks, including Anglo Irish, which were essentially unsalvageable. To stabilise the others it was forced to take on their bad loans and inject capital of some €35 billion. Because the guarantee had allowed large groups of bank creditors to walk away scot-free, the full burden of the bailout fell on taxpayers. Once the bills were in, the total cost came to €64 billion, or some forty percent of GDP.

The blanket guarantee left the government in the worst of both

worlds. Not only was it cripplingly expensive for the state, ultimately it was not even successful. As the loss figures kept growing, confidence in Ireland as an economic entity eroded badly, and foreign depositors and bond investors began to abandon the country—though part of this was also in response to the wider European situation. The Greek debt crisis of early 2010 raised the prospect of a cascade of sovereign defaults across Europe and drove the cost of borrowing for the Irish government to punitive levels. The authorities had managed though to put some reserves aside and could afford to avoid tapping the market for months. In Greece, the crisis was precipitated by the threat of a government default on its debts, but in Ireland this was not the primary risk.

The main problem lay in the banks. By mid-2010, a kind of slow motion bank run was set in train as €150 billion in cash was pulled from the system. Talk of bank runs conjures images drawn from grainy black and white 1930s photographs, of frantic crowds carrying suitcases, pushing and shoving to withdraw their savings. Ireland did not face one of those street-centred panics. It had to deal with something more silent and invisible: a 21st century digital run, where billions of Euros could be withdrawn from a bank in Dublin with the click of a mouse by an anonymous person sitting at a terminal in London or Frankfurt or Zurich.

Luckily for Ireland, as part of the Euro system, the banks did have the right, provided they post adequate collateral, to tap the European Central Bank for funds. This facility is designed as a backstop, only for use in emergencies and then only temporarily. That summer, Irish banks borrowed more and more from the ECB, owing over €150 billion by the fall. In the world of global finance this is not an outstanding number. But €150 billion was the size of the whole Irish economy. It was now clear to most senior officials across Europe that Ireland would not be able to weather this storm alone. It would need a bailout of some kind.

While the lifeline, provided by emergency loans from the ECB, did prevent the complete collapse that typically overtakes countries with a foreign run on their banks—such as Argentina and Iceland—it also allowed Irish politicians to dodge any serious measures to resolve the situation. Recognising that having to go cap in hand to the Europeans would be viewed as a moment of national humiliation, a confession that the country had failed to keep its own house in order, Irish politicians kept stalling in the hope that something would turn

up, or with the delusion that perhaps the whole thing might blow over.

As oil industrialist John Paul Getty observed, "If you owe the bank $100, that's your problem. But if you owe the bank $100 million dollars that's the bank's problem." It was Ireland's bankers at the ECB who eventually brought the crisis to a head. More and more anxious by the day about the €150 billion it had at stake in Ireland, the ECB began to put pressure on Dublin to follow Greece and apply to the European Union for a bailout. In a move that generated much bad blood, it started a whispering campaign, leaking its doubts to reporters about Ireland's ability to go it alone. The Irish government continued to insist that it would not need a bailout. But a country as

As far back as 2004, these reviews had begun to sound a faint alarm over Irish real estate, each dutifully warning that house prices were too high and that Irish banks were channelling too much money into real estate lending.

dependent on foreign capital as Ireland cannot survive without the confidence of others. When it is forced to deny talk that it is in deep trouble, particularly if those rumours originate from its own central bankers, then it is almost by definition in deep trouble.

After a flurry of secret meetings—in Seoul where the G-20 was holding a summit; in Brussels where the Eurozone finance ministers were meeting; in Berlin and in Frankfurt, the headquarters of the ECB—on November 21, 2010, the Irish government formally applied to the European Union and the IMF for assistance.

Until this point, the Fund had been more of a bystander to the Irish drama. As with all its member countries, every year it would send a team to Dublin to conduct an annual economic review. As far back as

2004, these reviews had begun to sound a faint alarm over Irish real estate, each dutifully warning that house prices were too high and that Irish banks were channelling too much money into real estate lending. And every year, house prices kept rising.

Unfortunately the Fund also had the story only half-right. Believing that the Irish banks were in good enough shape, with ample capital to withstand any foreseeable bust, the Fund failed to connect the dots between the likely real estate crash and how this could set off a fundamental banking crisis. Its warnings were therefore somewhat muted.

Even after the crisis had begun, the Fund remained largely out of the loop. For example the government's decision to guarantee the liabilities of all banks was taken without consultation. As a member of the Eurozone, most of the dealings the Irish authorities had were with officials of the European Union; they saw the ECB as their first line of defence.

|

In 2009, Ashoka Mody, an Indian economist with a doctorate from Boston University, was appointed the IMF mission chief for Ireland. Mission chiefs play a pivotal role in the way the Fund conducts its business. Think of them as the platoon leaders of the IMF. While missions operate under a set of marching orders, which have been through several rounds of clearance within the Fund hierarchy, the mission chief typically knows much more than his colleagues and superiors about circumstances in the field. So because so much of what the Fund recommends depends on judgments about what is feasible under local conditions, mission chiefs are much more than cogs in an elaborate machine. They orchestrate the Fund's strategy towards a country. At headquarters, they may have a string of people looking over their shoulders, but once in the field they come into their own, and are granted a wide latitude to exercise their judgment.

Mody, a slight and intense man with dark-ringed, deep-set eyes, developed a reputation during his years at the Fund for being a perfectionist, for always having done his homework. As the mission chief for Ireland, he forged a strong working relationship with the then Finance Minister Brian Lenihan—a bond that became particularly close since they were both struggling with serious health problems. Lenihan was diagnosed with pancreatic cancer at the end of 2009,

and Ashoka had almost been killed by a gunman in Washington DC, an aggrieved former employee of the IMF it turned out. During the annual review in 2009, and again in early 2010, Mody urged Lenihan to take advantage of the IMF's credit facilities and borrow pre-emptively. Mody saw this both as a way of shoring up Ireland's finances and using the IMF imprimatur to bolster foreign confidence in Ireland. But both times, either Lenihan was not himself persuaded, or he was unable to convince his cabinet colleagues. Until early 2010, it was still not clear what role the Fund should play in bailing out troubled European countries. Many officials, in Europe and outside—in the US and Canada especially—believed that the crisis within the Euro should be handled solely by European institutions. The sums involved far exceeded the amounts that the Fund, given its resources, could prudently put into any one country. But when Greece erupted, the German Chancellor Angela Merkel developed doubts about Europe's ability to handle it alone. Overriding the objections of officials within Germany, including her own Finance Minister, Wolfgang Schäeuble, and in the ECB, she pressed to include the IMF among the lenders. In her view, it had the expertise for dealing with countries in trouble, which both the European Commission and the ECB lacked; it was not subject to the same political pressures as were European institutions like the European Commission; and it would be seen as objective, thus shifting the political spotlight away from Germany. As a consequence three parties, the European Central Bank, the European Commission and the IMF—which together became known as the Troika—oversaw the Greek bailout package. When Ireland found itself in trouble later that year it seemed sensible to rely on the same arrangement.

Because of the high profile nature of an Irish bailout, which would make the country the third largest borrower from the Fund, the IMF team was led by Mody's boss, another Indian, Ajai "Jai" Chopra. Over a 32-year career at the IMF, Chopra has had a natural instinct for trouble spots. And since trouble is the Fund's business, this has constantly placed him in the thick of things. In the late 1980s he worked in Latin America during the debt crisis; then in the early 1990s, he shifted to the Poland desk as East Europe embarked on its transition from communism to a market economy. During the Asian crisis of the late 1990s, he landed up in Korea, and in the early 2000s he moved to the European Department, and was there when problems with the Euro emerged.

With his thick head of greying hair, bushy eyebrows and glasses, at

first blush Chopra looks like one of those buttoned-down characters in a movie about the Cold War. In fact he turns out to be quite the opposite—soft-spoken, charming and articulate, with the polished tones of an upper class Indian, the product of his education at two of Mumbai's elite schools, Cathedral and Elphinstone.

Although the Fund had not originally found itself on the Irish front line, Chopra and Mody, as we have heard, had been keeping a close eye, and trying to develop contingency plans should the IMF be called in. Designing the right bailout package for Ireland posed two challenges. Firstly, the country was struggling with two potentially disastrous conditions: a gaping hole in the budget and a run on its banking system. The IMF team had had plenty of experience with countries whose public finances were in terrible shape—for example in Latin America in the 1980s. They had already had to deal with banking crises, especially during in the Asian crisis. Most of the Asian governments though had been in reasonable financial shape. It was rare, though not unknown, to have to cope with both problems at once; it was like dealing with someone simultaneously undergoing kidney failure and a heart attack.

Secondly in Ireland, the IMF had to work with a limited toolkit. In the cases of most countries in financial trouble, one way to curb spending while offsetting the negative impact on the economy is to devalue the exchange rate. A cheaper currency makes the country's products more competitive in the world market, thus giving exports a boost. That technique could not be applied in Ireland because, as part of the Euro, its currency could not be tampered with.

When the Troika mission arrived in Dublin, they were presented with a so-called National Recovery Plan. Even though the politicians had been slow to acknowledge the need for a bailout, Irish Department of Finance officials had finally seen the writing on the wall and had begun work on a further austerity package. With the capital markets now shut to Ireland, and thus unable to borrow any more, they recognised that cutting the deficit was no longer a matter of choice but of necessity. Sensing the national mood more likely to accept homegrown measures rather than imposed ones, the Department of Finance developed its own package of cuts. A senior Irish official described to me how several weeks before the Troika flew in, he and his colleagues had pulled a whole pile of past IMF programmes from the files to be used as templates for what was required.

The National Recovery Plan provided for a cut of €15 billion in

deficit over the next four years, on top of the €10 billion in savings already made over the previous two years. About €5 billion was to come from increases in taxes and €10 billion from expenditure cuts.

When a Fund programme is being put together, budget negotiations tend to be the most difficult, acrimonious part. Raising taxes or cutting spending is politically difficult. Moreover, crises stretch the limited capabilities of governments, so it is often the Fund that ends up putting the package of measures together, reinforcing the notion that the cuts were imposed from outside. To be presented with a well-developed package, as the Fund was in Ireland, was unusual. The negotiations over fiscal policy proved to be relatively straightforward, though there would be some argument about the pace at which measures should be implemented.

The real challenge was the banks, where the most immediate—and crucial—task was to stop the run. Bank panics usually occur because depositors and other creditors have no way of knowing which bank is solvent and which not. Assuming the worst, they pull their money out of all banks indiscriminately. The protocol for dealing with these panics is now pretty well-established: figure out as accurately as possible the magnitude of likely losses, and take over and quarantine those banks that have been irreparably damaged and have no chance of surviving. For the others that are at least partially healthy and have some chance of surviving, excise the cancer by moving the bad loans off their books, and inject enough public money so that they can limp back to business. The whole strategy is based on reassuring the depositors of the banks that remain standing that their money is safe. The difficulty in Ireland was that the authorities—having so consistently underestimated the size of losses since the beginning of the crisis—had lost all credibility. No one trusted them anymore.

To try to reassure lenders that the hole in the banking system was manageable and to assuage the fears of depositors, the Troika proposed that the Irish authorities bring in a third party with a reputation for independence and objectivity. In this case the investment firm Blackrock would go through the banks' loan books with a fine-toothed comb, pass judgment on the true quality of the loans, do an audit of the losses, and conduct a series of tests on the resilience of the banks to more bad news, should the economy deteriorate further.

A Fund mission chief has to be part technical economist, part diplomat, and part politician. The technical challenge was to get the balance right between measures to stabilise the budget, and measures

to stabilise the banks. Excessive austerity would so drastically weaken the economy that it would tip the banking system over the edge. Go too easy, and any remnants of confidence in Ireland would evaporate, sending foreign depositors heading for the hills. In such an emergency, there is no scientific way of ensuring in advance that the balance is just right. Compounding the technical difficulties was the diplomatic challenge of conducting four-cornered negotiations between the government itself, the ECB and the European Commission, and the Fund, each having come to the table with its own perspectives and interests, diagnoses and prescriptions.

Indeed the biggest disagreements did not occur between the Troika and the Irish government, but within the Troika itself. The ECB wanted to see €8 billion of budgetary cuts up front, while the Fund staff, worried that this might undermine bank stabilisation, pressed for a smaller number—€4.5 billion. They eventually settled on a compromise of €6 billion. As Chopra reminded me when I met him in Washington, this was rapid battlefield surgery. No one could be sure whether the package they had put in place would succeed in stabilising the banks, or whether the fiscal austerity package was too harsh and would cause the economy to plunge further.

As always the bailout was hammered out against a fraught political background. The government was now deeply unpopular, seen to be incompetent and having lost control. The press carried overheated rhetoric about the loss of economic sovereignty, a theme that carries much emotional resonance in a country that had once been so dominated by a foreign power, and that had fought so bitterly for so long for independence. When the budgetary measures were unveiled in Parliament, the opposition finance spokesman Michael Noonan declared, "This is the budget of a puppet government, which is doing what it has been told to do by the IMF, the EU commission, and the European Central Bank." A few months later, the government fell; Noonan became finance minister and for all intents and purposes, executed the same policies that he had previously denounced.

The part that aroused the biggest political furore at the time, and that haunts policy makers to this day, had to do with the cost of bailing out the banks. Since 2009, as estimates of the amount that the government would be forced to inject to cover their losses kept growing, public anger and frustration had mounted. Why should taxpayers be saddled with the mistakes and misjudgements of a bunch of greedy bankers? The 2008 guarantee had granted a good fraction of the bank

bondholders—most of them foreigners—a reprieve, in effect allowing them to withdraw their capital without any losses.

At the time of the Troika bailout in November 2010, some €20 billion in bonds no longer covered by the guarantees remained outstanding. During the negotiations, the government, faced with an electorate outcry over its excessive generosity, tried to shift some portion of the burden of salvaging the banks onto the remaining rump of bondholders. While the IMF team sided with the government, the ECB vetoed the idea, believing that it would precipitate an unstoppable investor panic as fears spread across Europe of sovereign and bank defaults. Though the Irish eventually conceded the point under duress, they believed then, and continue to harbour the notion now, that they had abstained from pursuing their own national interests in the wider interests of European economic stability. In effect they took one for the team, and so still believe that the ECB owes them one.

|

In November 2010, Ireland received a bailout of €85 billion, the European Union providing €45 billion, the IMF €22.5 billion, the remainder coming from a rainy day fund built up by the Irish government during the boom times. When a country borrows from the Fund, it usually does not receive all the money at once, but in tranches, in this case over a three-year period. Every three months a mission is dispatched from Washington, another from the European Union in Brussels and a third from the ECB in Frankfurt, to monitor how well the country has been meeting its conditions, whether those conditions need to be adjusted in the light of changing circumstances and whether to recommend that a further tranche of the money should be disbursed.

The mission that I accompanied in October 2012 was the eighth in the two years since the bailout had been first agreed to. The mission chief, who had taken over the reins from Jai Chopra, was a New Zealander named Craig Beaumont. Educated at Victoria University in Wellington and the LSE (a large number of the IMF staff seems to have passed through LSE at some point), he had worked at the Reserve Bank of New Zealand before coming to the Fund. In his mid-forties, with rimless glasses and greying temples, he looks as if he might be a research scientist, a numbers guy like most that one meets at the Fund. He has a deliberative manner, he chooses his words

carefully and believes in sweating the details.

Being the mission chief to Ireland was a high-profile job. The problems in Greece had cast doubt on the Troika's strategy for dealing with European countries in trouble, so much was riding on a success in Ireland. There were many moving parts to the Irish programme—reducing the budget deficit, slimming down the banks, cleaning up their balance sheets, and finding a way to get exports moving and lift the economy out of its slump—which made it unusually complicated. Adding to the complexity, agreement on each of the components had first to be reached with the two other members of the Troika, before it was proposed to the government. Craig was obviously viewed by his superiors as a safe pair of hands, someone to be trusted with a difficult and delicate assignment.

The mission consisted of ten people, each assigned a separate task. Emilia Jurzyk came from Poland but had a doctorate in economics from the University of Louvain in Belgium. Her job was to nail down the projections on the economy. Jochen Andritzky, a German who had received his degree from the University of St. Gallen in Switzerland, was assigned to the forecasts of Ireland's debt. Alexandre Chailloux was the expert on anything to do with the monetary plumbing of the Euro system. A French national, before coming to the IMF he had been at the ECB and the Banque de France. Gavin Gray, a Scotsman with a degree from the LSE, had come to the Fund from the UK treasury. His job was to analyse the funding gap—how much money the Irish would need to plug the hole in their finances. Syed Ali Abbas, the budget expert, an Oxford-educated Rhodes scholar from Pakistan, had worked on Ireland since November 2010 when the loan was first negotiated.

Also joining the mission was Peter Breuer, the IMF's resident representative in Dublin, in other words the Fund's eyes and ears on the ground. Though he was a German national, his education spanned three continents—high school in Singapore, a BA from Vassar College, an MA from LSE and a doctorate from Brown. Craig's deputy mission chief was Ashok Bhatia, who somewhat unusually did not have an advanced degree in economics but had studied aerospace engineering and finance at Imperial College London. Before coming to the Fund, he had worked for Standard and Poor's, rating the debts of governments around the world.

All were in their thirties or early forties and had typically been at the Fund less than ten years; because the Fund moves people around

every couple of years, none could have been considered an expert on Ireland. Several had only been there a couple of times before. But they had been to various other places in their careers. Emilia had worked on Moldova and Latvia, Jochen on the Ukraine, having even lived in Kiev for a couple of years. Alexandre had just come off an assignment in Iceland, whose travails were often compared to Ireland's; Gavin's experience had been in Latvia; Ali's in Sudan and Vietnam; Peter's in Uruguay, Argentina, Paraguay, Peru and most recently Bulgaria; while Ashok's had been in Asia and, most tellingly, as a member of the Fund's US team during the whole financial crisis.

Fund officials recognised from day one that the key to recovery for the Irish economy would be to clean up the banks. This was a highly

On the one hand, Ireland was being touted as one of the Fund's success stories—indeed that very week the country's supposed comeback had made the cover of Time magazine.

technical exercise. From the outside, it is often hard to tell whether a loan is a good loan or a bad loan. Bankers can easily disguise potential problem loans by channelling additional funds to borrowers in trouble, who use the new cash to service their existing debts. The ability to keep throwing good money after bad allows bankers to postpone having to recognise a bad loan, mask their problems from bank regulators and even delude themselves about the true magnitude of their own problems.

But because the banking system had got itself into such deep trouble, it almost had to be surgically reconstructed. So in addition to the economists on the mission came two experts with extensive experience in dealing with sick banks: Mike Moore, an American who had worked for a long time at the Fed, and Joaquin Gutierrez

Garcia, from the Bank of Spain.

Clearing this overhang of bad debts threw up a host of complicated legal issues—from laws on foreclosures and personal insolvency to the closing down of banks. So Maike Luedersen joined the mission, a legal expert from Germany who was the longest serving team member, having worked on Ireland's case since 2009.

The mission members, as well as the teams from the European Commission and the ECB, stayed at the Merrion, a charming row of Georgian townhouses, famous for being the birthplace of the Duke of Wellington, now converted into a boutique hotel. With its elegant drawing rooms, filled each afternoon with Dublin society ladies taking tea, with its burning peat fires, and delicate rococo plasterwork, this was a somewhat incongruous home for the thirty-odd international bean counters who used to descend every three months. But the Merrion sits directly across the road from the Ministry of Finance, so in the morning the mission had barely a twenty metre commute to work. Everyone with any Government financial business seemed to stay there. One afternoon, I bumped into Larry Summers emerging from the hotel, flanked by a group of officials as he headed across the street. The next morning we saw him having breakfast in the restaurant with Bono.

On the first night of the mission, Beaumont collected the team in the small second floor suite, which was to be their headquarters for the next ten days. Not everyone had arrived. Some of those that had, had flown in overnight from Washington DC; others had come through Europe. They were in an ambivalent mood.

On the one hand, Ireland was being touted as one of the Fund's success stories—indeed that very week the country's supposed comeback had made the cover of Time magazine. On the verge of a banking collapse when the bailout package had been put in place, its economy down by fifteen percent in two years, its budget deficit running at twelve percent of GDP, no longer able to borrow in international markets, its unemployment at fourteen percent, it confronted the real prospect of an overall economic implosion that would have forced it out of the Euro. Two years later it had stabilised. By shrinking their business and selling assets, its banks had cut their borrowings from the ECB in half. The country had consistently been meeting all its loan conditions and indeed where the budget was concerned, it had been exceeding them—its deficit had come down to 7.6 percent in 2012. In the words of one senior official, its strategy over the last two years had been to

under-promise and over-deliver. In July it had successfully returned to the bond market to borrow. Within the Fund, the government's success was attributed to its "ownership" of the program, which is Fund-speak for the fact that the fiscal measures were largely conceived and put together by the government rather than imposed by the Troika.

On the other hand, the mission members were acutely aware that significant problems remained unresolved. The banks had been slow in untangling the overhang of mortgage arrears on their books, determining which loans were to be foreclosed on and which needed to be written off. Without some clarity on the extent of bad loans, the banks would remain paralysed.

Furthermore, the programme's original forecast was that Ireland's economy would be growing by now, but faced with international and domestic headwinds, growth had been a lot more sluggish than predicted. Unemployment remained obstinately high. Emigration, which historically had been Ireland's safety valve, had accelerated. Young college graduates, unable to find jobs at home, were heading off to Germany or Australia. But all those unemployed ex-construction workers without college degrees were not readily employable either outside Ireland or at home, in the dynamic sectors of manufacturing such as high-tech and pharmaceuticals. No one was quite sure what to do about the imbalance.

Every morning after breakfast the missions would head off across the road to the imposing Edwardian building which the Department of Finance shares with the prime minister's office. Its neoclassical granite façade is typical of the government offices favoured by the British in the last stages of imperial grandeur—this one was completed in 1922, just as they were getting ready to leave Ireland.

The mission would then spend the whole day meeting with mid-level government officials, usually in the ground floor conference room of the Treasury Building, though sometimes at the Central Bank of Ireland, housed in an ugly 1970s building near Trinity College. The building resembles a top-heavy cube perched on a pedestal, and to my mind looks dangerously unstable, an unfortunate feature for the headquarters of any central bank, which should seem solid and secure.

At these meetings participants discussed some of the future policies—tax increases, cuts in spending, changes in credit policy—which the government was contemplating. This was sensitive territory, and any leakage of the talks' substance could have potentially moved

markets and caused political tensions. Not surprisingly, the Irish authorities were reluctant to have an outsider like me privy to such discussions. Though they did agree to brief me on background details off the record, they refused to permit me to join any of the meetings between the Fund staff and their officials.

It was nonetheless apparent that the mission did more listening than talking. They were not there to run Ireland's finances but to look over the government's shoulder, to judge whether its numbers hung together, and as one official put it, to hold its feet to the fire.

After a hurried dinner, most frequently in the pub at the back of

Despite the fifteen percent unemployment and the twenty-five percent cut in the standard of living of the average Irish person, there had been few street protests in Ireland on the scale of other European countries such as Spain and Greece

the Merrion, the mission members would regroup to discuss what they had learned that day. The two main items on this particular mission's plate were the problem of mortgage arrears and, as usual, the budget. With house prices having halved and incomes having fallen by twenty percent, it was not surprising that droves of families were behind on their mortgage payments. One calculation had one out of every seven mortgages in trouble. At an earlier mission, the Troika had set targets for the banks to clear some of these late mortgages, either by restructuring the loans to reduce the principal payment or by foreclosing. But as usual the banks were behind on their targets, so the mission had to decide what, if anything, should be done.

Government finances are a perennial focus of these review missions. While Ireland had more than met its deficit goals the previous year, it had overrun on healthcare spending and, given the continued high jobless rate, on unemployment benefits. The government only managed to come in under target by letting more public employees go, and because tax revenues had been surprising on the upside.

Ali Abbas, the fiscal expert, had been working his contacts, and outlined what he had gathered to forecast for the coming year. Ali, with his deep and easy laugh, his expansive manner and gregarious personality, was the exact opposite of whatever caricature one might have of a budget expert. Having worked on the budget since the programme had begun, he knew people up and down the bureaucracy. He also knew much about Ireland's finances. One senior official described how he had handed him several hundred pages from the National Recovery Program one Friday evening, and at 7am the next morning received a call from Ali, who had stayed up all night going through the piece and wanted to clarify a question on a minor footnote.

This time Ali stressed that after four years of austerity budgets, which have exacted €20 billion in tax hikes and expenditure cuts (the equivalent of $6000 for each man, women and child in Ireland), much of the low-hanging fruit had been picked. The additional €8.6 billion needed to reach the ultimate target was going to be increasingly politically difficult.

Despite the fifteen percent unemployment and the twenty-five percent cut in the standard of living of the average Irish person, there had been few street protests in Ireland on the scale of other European countries such as Spain and Greece. In the week before the mission landed, a protest of 20,000 farmers had converged on Dublin. But that had had less to do with budget cuts than with proposed changes in the European Union's Common Agricultural Policy. When I asked why there were not more public expressions of anger, I received many different answers: that people blamed themselves as much as the banks for the housing boom; that the Irish preferred to emigrate rather than fight; that this was a fatalistic nation. A novelist friend argued that the troubles of the last few years paled in comparison to the tragedy of the civil strife that had afflicted Ireland during the last century.

No one said that they blamed the IMF or its policies. Of the three agencies involved in the bailout—the European Commission, the ECB and the Fund—it was the ECB that was the most resented. The ECB was Ireland's largest lender so some of this was the natural antipathy

of a debtor to its creditors. But during the run on Ireland's finances in the fall of 2010, the ECB had proved, according to a senior Irish banker, to be "very unhelpful"; it was known to have been the most hawkish in the negotiations, too single-mindedly focused on getting its money back.

The Fund by contrast was thought to have grasped the full dimension of the situation, displaying a clearer understanding of the nature and scale of Ireland's banking problems. It had been more perceptive of the social costs and political limits of austerity. It was widely known to have sided with the Irish in the closed-door budget negotiations and had pressed its Troika partners to do more to reduce the burden from the bank bailout.

The Fund had in the past had its share of truly clumsy public relations. Asians, for example, find it hard to forget the humiliating photograph that splashed across the world's front pages during the Asian Crisis of 1997, which showed the head of the IMF standing with his arms sternly crossed, like some foreign proconsul, while the President of Indonesia sat meekly before him signing the loan agreements. Having learned from its previous public relations disasters, the Fund tried its best to show greater sensitivity in the way it communicated with the Irish public. In the first year of the programme, the Troika held press conferences after each review meeting. Chopra revealed an unexpected flair for media relations at these events and was able to explain economic policy issues lucidly and simply. But most important had been his demeanour. In contrast to the mission chiefs from the ECB and the Commission, who had come across as faceless and emotionless Eurocrats, Chopra had showed empathy for the plight of the Irish, flavouring his responses with well-chosen allusions to Irish history. It also made him something of a minor celebrity in the country—in the early days of the programme, people would stop him in the street to shake his hand.

Generally few people within the Fund seem especially bothered by the unpopularity of the institution. Many treated it almost as a badge of honour, seeing themselves as economic doctors willing to prescribe harsh but necessary medicine. Nevertheless, even in Ireland where the IMF is favourably viewed, mission members did not like to advertise who they were when out in public. None had ever felt threatened, although a few months before, one had been accosted by a group from Occupy Dame Street, the Irish equivalent

of Occupy Wall Street, but had neatly sidestepped the confrontation by crossing the road. Still, things could always turn ugly if you were to encounter the wrong angry drunk in a pub.

For the most part they did not go out much, holed up in their hotel rooms preparing for the next day's round of discussions, drafting notes into the early hours of morning on their findings or sitting out late night brainstorming sessions. One mission member did confess that when out at some pub or restaurant, if asked what he did, he would describe himself as an "auditor"—not too far from the truth I suppose. Another, with a more flamboyant inner life, liked to claim that he was a professor of French literature.

What seemed to rankle the Irish the most was the feeling that the Europeans had let them down and still not done their bit to pay for the banks. The Fund faced a real dilemma. The goal of lending to Ireland was to give the country enough breathing space to get its finances in order. The Irish had more than done their part, meeting all their loan conditions. But while I was in Ireland, there was a growing fear that the country was unlikely to recover simply on its own efforts, however heroic. Some additional step by the Europeans to share the burden of the bank debt was going to be needed. In other words the success of the IMF's program would rest less on what Ireland did next, and more on what its Troika partners did.

As I left Dublin I felt as though I'd visited someone in hospital recovering from an emergency operation. There was little question that Ireland had been saved from a financial catastrophe. But it was far from in good shape.

I thought of Tolstoy's famous axiom from the beginning of *Anna Karenina*, "Happy families are all alike; every unhappy family is unhappy in its own way." When it comes to the economic prospects of nations however, the opposite seems to be true. Economies in trouble—the unhappy families—are all alike. But every successful economy—the happy family—is successful in its own way, drawing on something distinctive in its own make-up: a talent for producing engineers and a knack for technology in the case of India; a disciplined and cheap labour force in the case of China; an abundance of raw materials in the case of Brazil.

Though the many teams of economists running around Dublin could congratulate themselves on preventing a terrible collapse, none of them, it seemed, knew quite what it would take to nurse the country back to health.

Liaquat Ahamed

Maputo

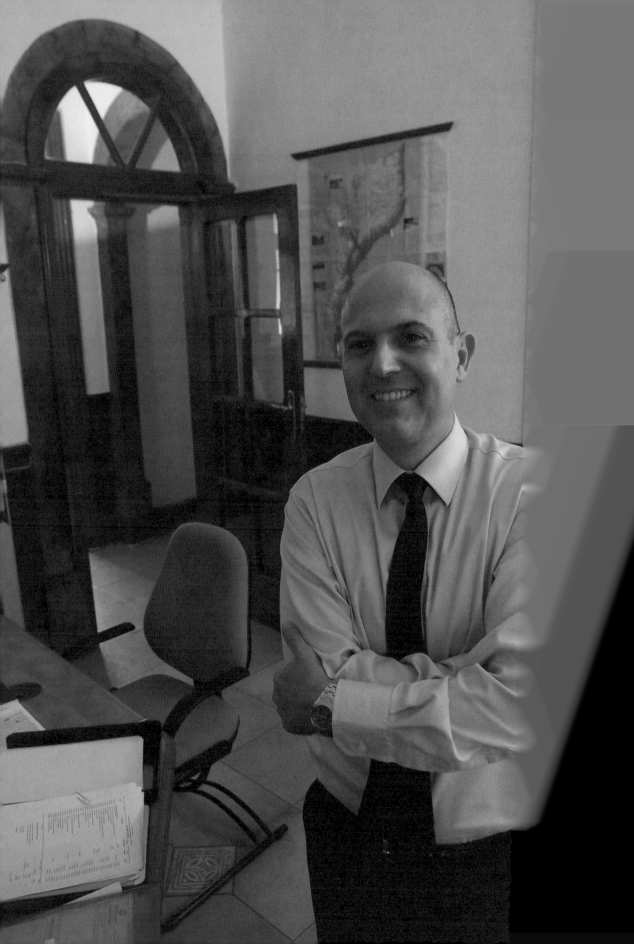

Every country, whether large or small, rich or poor, agrees to allow its economic policies to be reviewed and scrutinised when it joins the Fund. Usually conducted annually, but at least once every two years, these reviews are officially known in awkward bureaucratese as "Article IV Consultations", and the whole process is known within the Fund, with Orwellian undertones, as "surveillance." So even though only a fraction of the world's countries are borrowers from the Fund at any one time (about one in four in late 2012), these reviews enable it to stay involved with all its members. The hope has been that countries would come to think of them as annual medical check-ups.

Unfortunately, the 188 countries of the Fund are such a mixed bag that the notion that Article IV reviews would be like consultations between doctor and patient has not worked universally as a model. Not all of them need outside advice equally. In the smaller poorer countries like little Tuvalu, with its GDP of barely $25 million, the IMF's report is just about the only comprehensive review of the economy. But in the rich countries or even in the emerging market economies, where the central bank and Ministry of Finance might have several hundred economists on staff between them, IMF reports have to compete for airtime with a myriad of other pieces of high quality analysis, and a team of six economists might find it a challenge to have something new to add.

In some countries meanwhile the Fund faces deep scepticism about the value of its prescriptions. The gravest doubters come from the emerging markets of Asia and Latin America, who well remember the mistakes they believe the Fund to have made in the 1980s and 1990s.

The task of giving advice is made more complicated by the multiple objectives the Fund is trying to achieve with its reports. When I go for an annual check-up, I know that my doctor has a single concern: to counsel me on my health. I can rely completely on his discretion

and I should therefore be willing to confide in him. By contrast, the Fund in its consultations has to serve many constituencies and make a public diagnosis; an objective assessment of the economy that is of value to journalists, policy analysts, bankers, bond traders and politicians. It can be hard to reconcile the demands for transparency and independence to which a global financial institution is subjected with the privileged access that a "trusted advisor" requires.

It is in the middle-income and poor countries where Fund advice carries the biggest weight. For these are the countries that recognise, even if they are not currently borrowers, that they may one day have to turn to the Fund for financial help. To find out more about how the Fund stands with one of them, I headed off to Mozambique.

|

I flew into Maputo late one balmy November evening on a commuter flight from Johannesburg. A decade before the plane would have been at most half-full: the odd World Bank official, an expert or two from one of the innumerable European alphabet agencies in the aid business—NORAD, DANIDA, DFID, SIDA—a couple of earnest young humanitarian workers in cargo pants and t-shirts, and the occasional intrepid group of tourists.

This time around, many of the old familiar suspects were there (one cannot travel anywhere off the beaten track in Africa without encountering them). But the packed flight also included some very different types: a bevy of glamorous and talkative young Italians and Brazilians with their kids in tow, just back from a weekend of R&R in South Africa; a couple of grizzled roustabouts who sounded like they came from the West Texas oil fields; a few jaundiced-eyed South African businessmen in short-sleeved bush shirts.

I was booked at the Polana, the five-star hotel where Fund missions always stay. Constructed in a grand colonial style by the Portuguese in the 1930s, the Polana, its gracious verandas and terraces overlooking the Indian Ocean, was once renowned as one of the most elegant hotels in all of southern Africa. Maputo was then Lourenço Marques, a Portuguese city of wide boulevards and Mediterranean architecture in the heart of Africa.

During the Second World War, Lourenço Marques became the Casablanca of southern Africa, neutral territory infested by spies

from both sides. Malcolm Muggeridge, the noted British writer and journalist, then working for British intelligence at the MI6, operated out of the Polana, as did his counterparts in the German and Italian secret services, and his memoirs recount stories of his spy-versus-spy exploits through the hallways of the hotel. Particularly memorable was his attempt to sabotage the Axis war effort by sneaking out one night into the corridors to mix up the shoes of the German and Italian spymasters, left outside their rooms to be polished.

But the Polana's real heyday came during the 1950s, when Lourenço Marques became the holiday playground for whites from all over southern and eastern Africa, attracted by the more liberal attitude of the Portuguese to racial mixing, the legal gambling and relaxed social mores.

All these people had been brought to Maputo by two things: coal and natural gas. It was part of what was being called the "new scramble for Africa".

After independence in 1975 and the civil war that followed, the hotel fell into decay. Only a decade before, one would have encountered a dilapidated place of dark, dank rooms and broken elevators. But as with the flight over, much had changed over the last few years. The hotel had been bought by the Serena chain, owned by the Aga Khan, which had invested an enormous amount to return the hotel to its former glory. All its classical motifs, the columns along the veranda and the balustrades on the balconies, had been re-plastered and repainted, the red roof tiles restored, the Portuguese floor-work replaced, the old-fashioned elevator cages repaired, and the rooms refurbished.

Upon arrival, there appeared to be a party going on. The dining area overlooking the hexagonal swimming pool, where once German and British spies kept wary eyes on one another, was packed with the same sort of youthful and cosmopolitan crowd that had been on my plane.

Liaquat Ahamed

Because of the shortage of adequate real estate in Maputo, I discovered that whole families, most of them Brazilian, were living at the hotel. Speaking Portuguese, they seemed to be at home and brought their own cheerful exuberance to the atmosphere. On the veranda having cocktails were sleek dealmakers of every stripe—bankers from Dubai, steel men from Mumbai, oil executives from Rome, mining engineers from São Paulo—all in sharp suits. Periodically one would get up from his table and pace back and forth, talking loudly into his cell phone.

All these people had been brought to Maputo by two things: coal and natural gas. It was part of what was being called the "new scramble for Africa". The coal deposits—the largest to be found anywhere in the world over the last fifty years—were up in Tete in the remote north-west and could, within the next decade, make Mozambique one of the world's three largest exporters of coal. The biggest mine was owned by Vale, the Brazilian metals giant—hence all the Brazilians.

An even greater windfall had occurred the previous year when Anadarko, the American independent oil company out of Oklahoma, and ENI, the Italian energy giant, had discovered massive offshore natural gas reserves in the north-east, up by the Tanzanian border. These could vault Mozambique into the ranks of the top three or four exporters of natural gas, after only Qatar and Australia.

This had yet to materialise however, and for the moment Mozambique remained a very poor country—to some degree a legacy of war. In 1975, after a bloody war of independence from Portugal, Mozambique promptly fell into a seventeen-year civil war between Frelimo, the Soviet-supported Mozambique Liberation Front, and Renamo, a guerrilla force financed and encouraged by the South African apartheid regime. By the time peace was negotiated in 1992, it had become one of poorest countries in the world, with a per capita income of barely $100.

Even after twenty years of peace, by the IMF's reckoning, the 22 million odd Mozambicans who lived there had a per capita income of about $500, after adjusting for the cost of living about one-fiftieth of that in the United States or Western Europe. It ranks 185th out of 187 countries on the United Nations Human Development Index.

Yet the wealthy residential area surrounding the hotel, on the bluffs overlooking Maputo Bay and the Indian Ocean, belied Mozambique's poverty. Next door was the presidential compound. Though the complex was mostly hidden behind tall walls, one could see a monstrous office block being built. A giant crane painted

Liaquat Ahamed

with large Chinese characters towered over the scene.

But if one headed west from the hotel along Avenida Mao Tse-tung, after a mile one hit Avenida Vladimir Lenin and Avenida Karl Marx, parallel to which ran Avenida Guerra Popular, the Avenue of the People's War, which turned to be quite peaceful. This was the heart of downtown. In the same vicinity were streets named after Ghana's leader Kwame Nkrumah, radical Chilean politician Salvador Allende, anti-colonial leader Amílcar Cabral, and yes, even Kim Il-sung.

The downtown commercial district still looked and felt like the sleepy coastal port it once had been. The colonial buildings had run to seed and the shabby office blocks needed a paint job. Here and there one stumbled across the ruins of a building fallen victim to twenty years of war and neglect, occasionally an art-deco construction, once beautiful. Hawkers and pedlars were selling an assortment of maps, bootlegged CDs, sunglasses and key rings.

For a city of two million people, the centre of Maputo was small. Further west lived the middle classes in rows and rows of decrepit apartment blocks, all ten floors with grilled windows. Surrounding Maputo was a ring of shanty-towns, their red dirt alleys lined with open drains, rows of cinder block huts made with corrugated iron roofs weighed in place by an assortment of boulders and bricks.

O

One look at the Fund's office in Maputo and you get a hint of the unusual position the organisation occupies in Mozambique. For it has not set up house as in most places in the building of the central bank or some midtown commercial high rise, but in a single storey corrugated iron-roofed bungalow. Located on an acacia-lined street in a residential area near the Polana it has a giant mango tree in the backyard and was once the three-bedroom home of a middle class Portuguese family. When independence arrived in 1975, the family were given twenty-four hours to leave, and the house, like so many at the time, ended up in the hands of a mid-level Frelimo official as reward for his part in the struggle. Having moved back to his village, he now lived off the rent.

It was a peaceful neighbourhood of modest villas with little traffic. Occasionally Mozambican women would pass, carrying big baskets of produce on their heads. Next door lived a sibling of the original Portu-

guese official, who having decided to stay on after Independence, was still there forty years later. Across the street stood a Greek Orthodox Church, which to my surprise was open, though mostly empty, and a wedding hall that resembled a faux-Greek temple, where on weekends there was much singing and dancing. Further up the block, a crumbling mansion with exquisite Portuguese tile work has lain abandoned for the last forty years. This was once the headquarters of the colonial secret police, still haunted, legend has it, by the ghosts of the torture victims who died there.

Finding the IMF in such a home was like finding your Wall Street banker uncle living in a bohemian shack on Key West. And as I discovered, my instinct was right. In addition to its traditional role as

By the late 1990s Mozambique was receiving a further $500 million a year in budgetary support— equivalent to almost ten percent of GDP and thirty percent of government spending.

financial watchdog, the Fund has carved out an additional function as go-between, the result of the unique characteristics of Mozambique's public finances.

Once the civil war had been more or less settled in 1992, Mozambique, for reasons I don't quite understand, became something of a darling of the aid community. Perhaps it was the success of the peace accord and the transition without retribution to a semblance of democracy; perhaps the front line role it had played in the fight against the white apartheid regime of South Africa. Whatever the reason, donor money poured in.

Because of the country's poverty and inability to cover day-to-day government's operations out of tax revenues, donors agreed to provide to fill the gap. And so beside some $500 million a year towards

Liaquat Ahamed

traditional development projects, by the late 1990s Mozambique was receiving a further $500 million a year in budgetary support—equivalent to almost ten percent of GDP and thirty percent of government spending. Aid flows became a crucial and necessary ingredient of macroeconomic stability.

In 2000, after the ex-Marxists of the ruling party, Frelimo, had discovered the inestimable benefits of unbridled capitalism, Mozambique experienced a bank crisis, an almost customary rite of passage for countries in transition to a market-oriented economy. Banco Austral, a joint venture between a privatised local bank and a Malaysian consortium, went belly-up after several hundred million dollars of politically motivated loans that were unrecoverable. When the government stepped in and bailed it out with public money, there was outrage—familiar to those of us whose countries have been through their own bank bailouts. The difference was that in Mozambique this money came from the donors, who had been providing roughly thirty cents of every dollar spent by the government. Justly furious their aid dollars were paid out to politically connected bankers, they threatened to suspend all aid. The government, most of whom had been freedom fighters in the war against Portuguese colonialism, took offence at what it saw as an unwarranted intrusion on its sovereignty and dug in its heels.

Without cash from the donors, there would have been a vast hole in the budget, which would have undermined the Fund's attempt to maintain financial stability in Mozambique. Unlike the donors, it had preferred access to the government and felt compelled to assume the role of mediator. Over several fraught weeks an agreement was forged. The Mozambican government agreed to make a more vigorous effort to recover the bad loans and prosecute those responsible for looting the bank. In return the donors maintained aid flows. Though no one was eventually prosecuted—not surprisingly, since many of the offenders were part of the inner power circle—some portion of the loans was recovered and both sides could claim a measure of success.

Following the 2000 bank crisis the Fund found itself increasingly in the position of a broker between the government and the aid community, a role to be reprised in 2009. After the peace accord of 1992, though Frelimo continued in power, it had committed itself to reasonably open elections, and while these were never completely free and fair, there was enough of a semblance of democracy to keep the donors satisfied. During the 2009 elections, however, evidence of abuse was

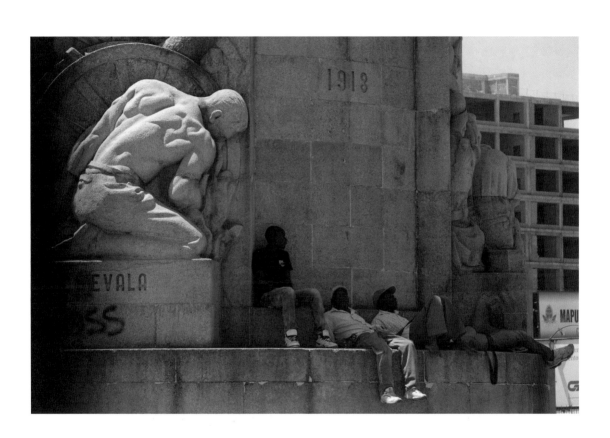

too great to dismiss. Again donors threatened to withhold budgetary support, and relations between them and the government seemed once again to be on the edge of spiralling out of control. Again the IMF staff, led by the then mission chief, Johannes Mueller, felt compelled to step in to arrange a deal, this time persuading the government to reform the electoral law and allow the opposition a greater voice in parliament.

The IMF's man in Maputo these days is Victor Lledo, a baby-faced Brazilian with a doctorate from the University of Wisconsin. With his background in political economy (his doctoral thesis was on fiscal federalism in Brazil), and the instincts of a political dealmaker more than a technical economist, he is in many ways an ideal go-between.

In September 2010, the government increased the controlled prices of bread, electricity and water, and allowed a rise in the tariffs on Chapas, the usually overcrowded, often rundown, and notoriously unsafe private minibuses that most Mozambicans use to get around. In the shantytowns that encircle Maputo, whose commuters were dependent on Chapas to get to work, riots broke out, and for some days the city was on lockdown, offices were closed and no one dared venture into the streets. The police reacted with excessive force, which kept looting out of the city's affluent areas but cost much in bloodshed. A dozen people were killed and hundreds more injured.

Victor had only arrived in Mozambique with his wife and young son a few months before. Even before order had been fully restored, while movement in the city was still restricted, he, his counterparts at the World Bank, and some of the other donors, put together a proposal by which the government would partially roll back the tax hikes, followed by a gradual phasing in of price increases.

Until then most economists in Maputo had viewed Mozambique as by and large an economic success; its growth fuelled by aid flows had been close to ten percent since the end of the civil war. The riots now raised fundamental questions about the nature of that growth and who the beneficiaries had been, particularly over the last five years. The IMF set to work on a proposal for expanding subsidies, though trying to target them more effectively on the poor.

Undoubtedly a factor that gave the government some room to alter course was that it had a little more money to spend. Despite being run by a bunch of ex-Marxists, it has been exceptionally adept at attracting donor money, which still covers thirty percent of its budget. Moreover, given its level of poverty, Mozambique has

147

actually done a pretty good job of raising tax revenues.

The events of 2010 took place as a push came from the very top of the Fund for it to show that its focus on macroeconomics did not preclude a concern for social issues. The expansion of the Fund into the broader dimensions of economic policy also happened to coincide with a somewhat novel approach to doing business, which has expanded its influence in countries like Mozambique. With aid flowing, Mozambique had no current need for IMF money. But donors increasingly sought comfort that the IMF was fully engaged and keeping an eye on things. As such, the Fund came up with what could be described as a virtual program, designing a policy package for Mozambique with the sort of conditions—for example limits on the amount that banks could lend to the government to finance the budget deficit—that would have been imposed were Mozambique to borrow from the Fund. Every six months, a mission came out to Maputo to assess whether these conditions had been met. But no money changed hands. In effect the Fund has served as a kind of rating agency for Mozambique, with the ability to give it a stamp of good housekeeping.

As the Fund set out to design the rudiments of social safety for the country, it has found itself with some odd bedfellows. Many in the local development community—the sort of people who work for UNICEF or the ILO—can remember the 1970s and 1980s, when countries all around the world had cut social expenditures under Fund pressure to bring their budgets under control. For most of their careers they have nursed a cynical view of the IMF. While I was in the country it was apparent that Victor seemed to take great satisfaction in demolishing their stereotypes of the institution in which he works.

S

Spend any time in the company of development economists and at some point one is bound to discuss why some countries succeed and others so terribly do not; why some governments seem to manage their affairs for the benefit of the public good, and others are run as rapacious kleptocracies.

Over lunch one day, as Victor and I sat on the terrace of his beautiful home on Avenida Friedrich Engels—somewhat incongruously, given its name, one of the most elegant streets in the city—we discussed the

comparison constantly mooted between Mozambique and Angola. Both were Portuguese colonies that, after an armed struggle, had independence arrive almost overnight in the 1970s when the Portuguese junta was overthrown; both ended up in civil war, and found themselves frontline states in the armed struggle against the South African apartheid regime. Colossal oil discoveries have made Angola much wealthier on paper, although I suspect the average Angolan is not much better off than the average Mozambican. Now that Mozambique stands on the verge of its own natural resource boom, the comparison has resurfaced. Everyone was asking whether Mozambique would become another Botswana, with its remarkably clean track record of economic management, or another endemically corrupt Angola?

I asked Victor why, for instance, Mozambicans seem to have been so open to Fund advice, whereas by all accounts in Angola, IMF officials were received with deep suspicion. Victor had obviously thought long and hard about such issues and came up with plentiful answers: the empowerment of technocrats versus politicians, the strong grass root links of the government due to the freedom struggle. Eventually we came to the conclusion that ultimately it had to do with so many intangibles—subtle variations in culture, the contingencies of history, the ethics of the leadership—that a simple explanation would be impossible. Over the following days, this question of Botswana or Angola would keep coming up.

While I was in Maputo, a so-called IMF technical assistance mission was also in town, its purpose was to help the government figure out how it was going to handle the forthcoming swell of natural resources. By one calculation, the coal and gas discoveries would increase GDP by more than a half over the next decade.

The mission comprised five specialists from the Fiscal Affairs Department. Its chief was Alex Segura, who in the last few years had made himself one of the Fund's experts on the problems of resource-rich countries. He was Spanish, though he preferred to call himself Catalan, with a doctorate from Columbia and a Peruvian wife. His colleagues were Marcos Poplawski Ribeiro, a Brazilian with a doctorate from the University of Amsterdam, married to a Dutchwoman; Christine Richmond, a Canadian with a doctorate from UCLA married to a Portuguese; Giovanni Melina, an Italian with a doctorate from Birkbeck College, University of London; and finally Apolinar Veloz, a Dominican with a Master's from one of the premier economic institutes in Mexico City, who had most recently been Deputy Minister of Finance of the

Dominican Republic. In sum, the usual representative sample of world citizens typically found at the Fund. It is probably no coincidence that every one of them had attended a major university outside his or her home country and that almost all had met their spouses there—a reminder that the world's great universities have become one of the crucibles of globalisation.

Because the team was not engaged in any sensitive or confidential negotiations, but was simply on a fact-checking mission, they agreed to take me along for a day as they went from one government office to another.

In the morning we headed to the Ministry of Energy, housed in a rundown midtown office block with a broken elevator. After climbing several flights of stairs, the fourteen of us—eight Fund staff including me, four officials and two simultaneous translators—crowded into a tiny makeshift conference room with plywood partitions and spent a couple of hours poring over maps depicting the future of electricity grids and power plants for the next twenty-five years. A cranky air conditioner struggled to keep the room cool, though it made so much noise that just to be understood we had to turn it off periodically.

That afternoon we had an appointment at the Ministry of Finance, located on the promenade that runs along the north side of Maputo Bay. Built during the waning days of the Portuguese empire, it had pretentiously tall columns that gave it an artificial grandiosity: you could imagine Mussolini ranting from its second floor loggia. While the Director of the Treasury described the system for public budgeting, taking us in painful detail through the steps and procedures and cross checks that all line ministries must go through before the finance ministry could authorise any payments from government accounts, the mission members took copious notes. Finding this review of public accounting procedures excruciatingly dull, I stared out of the window at the scene outside: a ferry chugging slowly across the bay, hawkers waiting for the passengers to disembark, the occasional dhow floating by, palm fronds waving in the breeze, the air filled with the scent of burning leaves... I dreamt of strolling along the seafront for the rest of afternoon.

The mission's main purpose was to run a series of seminars on the experiences of other countries after natural resource discoveries. Rather than being a blessing, they can often turn out to be a curse. All that sudden money pouring into immature economies and desperately poor societies can cause huge distortions. Prices rise excessively

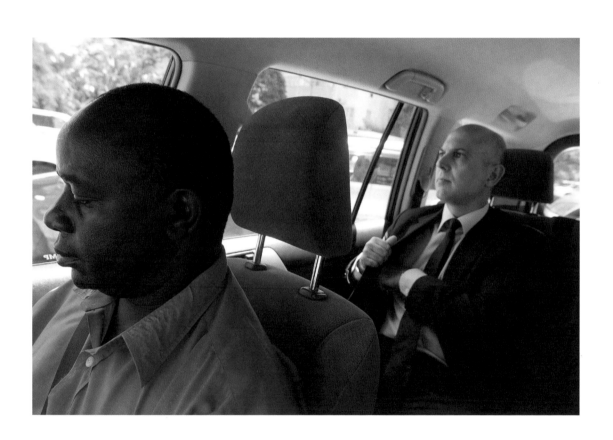

or else the currency is pushed up, making other industries, including agriculture, where most people are employed, highly uncompetitive. One has the paradox of a country that is in theory much richer, but where unemployment has actually risen, and the man in the street is poorer; where governments flush with cash waste the money on unproductive investments, or even worse just loot it.

The seminar was held in the conference room of a local hotel and for two days we went through case studies of how various countries had handled their newfound riches; the ones that had done it well—for example Botswana or Mongolia—and those which had made mistakes—Angola, Chad, Nigeria... a far longer list. We were taken through how Mongolia dealt with the problem of volatility; the rules Norwegians

The IMF staff had to be somewhat cautious in describing other countries' follies too explicitly —it would not have done if it had come out that Fund staff had bad mouthed one of its members.

followed in deciding how much oil revenue to save; the relative advantages of Chile's sovereign wealth fund over that of Chad's; how the government of Angola monitored, or more accurately failed to monitor, where its money was going; what the Mexicans did when oil prices collapsed in 2003; how Ghana handled the price spike of 2010.

The presenters tried to focus diplomatically on successes. But the twenty-odd participants, mostly mid-level officials from the Mozambican civil service, kept asking about the failures, the places where things had gone wrong, where politics had been allowed to trump economic sense. The IMF staff had to be somewhat cautious in describing other countries' follies too explicitly—it would not have done if it had come out that Fund staff had bad mouthed one of its members.

A mission to a less developed country like Mozambique would not

Liaquat Ahamed

have felt complete without its moment of drama. On the first day of the training session the government announced a long awaited hike in Chapa fares from 7.5 meticais a trip (the equivalent of 25 cents) to 9 meticais (30 cents). It was a similar fare rise to that of 2010, which had provoked several days of riots, so the whole city felt anxious. The night before a young economist from a local think tank warned me to expect trouble.

The next morning reports filtered in that protesters were burning tires and had barricaded the roads coming into the city from the west, forcing all Chapas services to be cancelled. With no transport from the outer suburbs, schools and many offices remained closed. Victor was called to a meeting on the security situation convened at the UN office. On his return he told his local staff to leave early. While no obvious sign of trouble was visible where we were, foreign visitors were advised to stay inside the hotel that evening. But by the next morning the city was once again calm and business returned to normal.

One evening I accompanied the mission for dinner on Avenida Marginal, the promenade along the north shore of Maputo Bay. Almost sleepy during workdays, on weekends this avenue lined with tall palm trees transforms into a giant tailgate party, jammed with traffic as beat-up cars, crammed with kids, cruise up and down the main drag. The air reeled under boom-boxes pumping out *Marrabenta*, the local dance music. Little stalls, often no more than a table, sold beer and young kids hung out on the sidewalk, laughing, drinking and dancing.

After a feast of the local speciality of grilled tiger prawns on the terrace of an open-air seafood restaurant, with a few beers under our belts, the staffers began to exchange war stories. One described how, in a certain African country, he uncovered several hundred million dollars in government spending that had been kept off the books. He stumbled across the fraud when he heard that many of the companies who were supplying the government were not being paid on time, and after some digging, discovered that large sums budgeted for legitimate government expenses were being diverted to a project sponsored by the president's son. The president, when confronted with the evidence, feigned ignorance and expressed his shock that such things were going on in his government. Eventually it was the budget minister who took the fall.

Another member of the team described how, with a colleague,

they once uncovered a black hole of over $30 billion, embezzled from the accounts of an oil-exporting country. Officials had, up until then, disguised the crime by fabricating the figures for oil receipts, but their efforts had been pretty amateurish, for they failed to recognise that accounts have to balance and that money claimed to be coming in had to show up somewhere. They had omitted to overstate the reserves in the central bank by a corresponding amount.

Listening to these tales of corruption and venality at the highest levels, I asked myself whether there was any point in conducting seminars for mid-level government officials on how to run an economy competently when all it took was some two-bit kleptocrat to undo it all. I decided however to keep my thoughts to myself that evening. I knew none of my companions would want to fall prey just at that moment to my cynicism.

We left the restaurant at 1am. The Mozambicans were still dancing in the street.

Epilogue

The Bretton Woods Conference, at which the IMF and World Bank were created, concluded on July 22, 1944. At the closing banquet John Maynard Keynes gave the final speech. He spoke movingly about the spirit of cooperation that had animated their discussions and spoke of his hopes for the new international organisations as embodiments of "the brotherhood of man."

The IMF is now so often the centre of acrimonious debates over economic policies and a place where countries jockey for power, that it is sometimes hard to recapture the idealism of 1944 when Keynes was speaking. Nevertheless as my few months with the IMF came to an end, that speech kept returning to me.

As part of my reporting, I had drawn up a list of the biggest financial rescues which the Fund has been party to over the last two decades. As I went down the list a feature suddenly struck me. When Thailand found itself in trouble in 1997, the IMF rescue mission to the country was led by an Indian, that to Indonesia by an Iranian, to Korea by an Austrian, to Brazil and Argentina by an Italian, to Greece by a Dane, Portugal by an Ethiopian, and Ireland by two more Indians.

I could think of no better symbol of Keynes' rather sentimental vision of the brotherhood of man than these diverse and improbable partnerships between the economic physicians in charge of the Fund and its patients.

Acknowledgements

Thanks to Alain de Botton for originally proposing the idea to me, to Caro Llewellyn at Writers in Residence for smoothing the way so well, to my agent, David Kuhn, for his ever wise advice and counsel and to Eli Reed for his wonderful photographs.

Thanks also to the whole team at Visual Editions—Anna Gerber, Britt Iversen, Leah Cross, Hannah Gregory and Jeremy Leslie. They were a joy to work with.

My biggest thanks must go to the many people at the IMF who spent so much time talking to me about what they did, especially the members of the various mission teams who allowed me to tag along with them. I am particularly grateful to David Hawley, who embraced the idea of the book from the very start. Among the IMF staff, special thanks to Nicole Laframboise, who shepherded me so expertly through the organisation with such enthusiasm and unfailing good humour.

As I describe on the first page of this book, it was almost thirty-six years ago in the atrium of the IMF that I set first laid eyes on my wife, Meena. Neither of us then could have ever imagined where life would take us. But with her as a companion it has been a wonderful journey. And so it is to her that I dedicate this book.

Liaquat Ahamed is the author of *Lords of Finance: The Bankers Who Broke the World*, about the lead up to the Crash of 1929 and the Great Depression. The book won numerous prizes including the Pulitzer Prize for History and the FT–Goldman Sachs Prize for Best Business Book of the Year and has been translated into sixteen languages.

Eli Reed joined Magnum in 1983. He is a Clinical Professor of Photojournalism at the University of Texas in Austin. He has worked on countless publications and television networks and has won numerous awards, including the 2011 Lucie Award Achievement in Documentary photojournalism.